IMAGES
of Rail

HORSESHOE CURVE

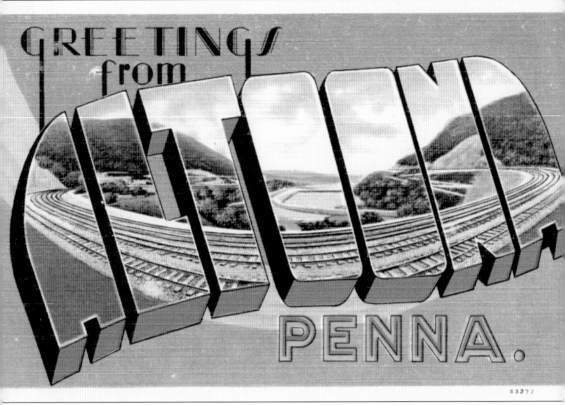

This linen-style postcard from the early 1950s clearly illustrates the Horseshoe Curve's association with the city of Altoona; it is the city's most notable geographical landmark. (Author's collection.)

On the cover: Seen here is a panoramic view of Horseshoe Curve and Kittanning Point from the west end. Pictured at what appears to be midday is an eastbound Pennsylvania Railroad passenger train, which is likely the *Pennsylvania Limited* around the 1940s, powered by a Pennsylvania Railroad class T-1 locomotive. The last T-1 locomotive was produced in Altoona in 1946, but all steam locomotives were off the roster by 1957, just 11 years later. No class T-1s survive in museums. (Author's collection.)

IMAGES
of Rail

HORSESHOE CURVE

David W. Seidel

ARCADIA
PUBLISHING

Published by Arcadia Publishing
Charleston SC, Chicago IL, Portsmouth NH, San Francisco CA

Printed in the United States of America

Library of Congress Catalog Card Number: 2007939606

For all general information contact Arcadia Publishing at:
Telephone 843-853-2070
Fax 843-853-0044
E-mail sales@arcadiapublishing.com
For customer service and orders:
Toll-Free 1-888-313-2665

Visit us on the Internet at www.arcadiapublishing.com

*Dedicated to the employees of the four railroads that have owned this
landmark through 2008, particularly those in the Greater Altoona area.
Their various shop or road crafts have served this landmark well.*

CONTENTS

ACKNOWLEDGMENTS

Any attempt to formulate a photographic history of the outstanding engineering and geographical landmark that is Horseshoe Curve is a tremendous responsibility. Many authors have preceded this work with much success, which makes this work that much more daunting a task. Photographic images came from many sources, including the author's collection of vintage postcards and photographs purchased at train shows, and most were personally taken by the author. However, photographic images, information, and encouragement came from many sources, particularly these individuals to whom I am indebted: Bob Airhart; Ted Beam; William (Bill) Burket; Angie Capriotti (sister of Oscar Salpino); Elaine Conrad; Scott Cessna (past executive director, Railroader's Memorial Museum); Wesley Cheney (Norfolk Southern Corporation); Anna and Lou Leopold; Don Baker; Brit Baker; Francis X. Givler (president, Horseshoe Curve Chapter, National Railway Historical Society); Leonard LeCrone; Thomas Lynam; Richard (Dick) Heiler; Railroader's Memorial Museum; William Haxel; Robert L. Hunt; Jody Kinsel; Dennis P. McIlnay, Ph.D.; Pat McKinney; Patrick McKinney; Larry G. McKee; Paul Molans; Tom Mugnano; Andy Mulhollen, D.O.; Neil Myers (director of operations, Railroader's Memorial Museum); Theresa Salpino; Virginia Seidel; and the membership of Horseshoe Curve Chapter, National Railway Historical Society, who provide much of the motivation for this endeavor. I am particularly indebted also to Bennett Levin and Eric Levin, whose passion for the Pennsylvania Railroad's heritage is a source of inspiration. Additionally, I must recognize Carl J. Amigh, block operator (tower) at Antis, Alto, MG, and AR, who knew the mountain well; Leroy Sheller, block operator/dispatcher, Altoona; Oscar Salpino for his railroad career as track foreman at Horseshoe Curve as well as caretaker at Horseshoe Curve park in retirement; Guy Lockard, concession stand operator for decades; Sheldon Burns, who photographed the curve extensively and counseled the author in photography; Thomas Lynam, photojournalist; Richard Heiler, historical photography preservationist; Robert L. Emerson; Peter Barton; Cummins R. McNitt; Barbara Cahoon; John Turkeli; Ric Tritsch; Richard A. Geist; Ray and Elizabeth Garvin; Mary Jo Wahl; Theodore J. Holland Jr.; Fred E. Long; John Conlon, retired assistant yardmaster, a highly respected historian on Altoona and its railroad history; Railroader's Memorial Museum, Altoona for its stewardship of this national historic site; and the legions of Maintenance-of-Way gangs. I have also received much counsel and inspiration from the retired railroaders of the Middle Division Transportation Committee: T. C. Quarry, R. F. Burkett, Ray Voltz, J. R. Conlon, C. D. Ferguson, R. C. Marlett, R. Swope, R. A. Jackson, C. H. Hazlett, Ed DelBaggio, F. R. Lynch, W. E. Chestney, C. M. Chestney, J. E. McGough, H. W. Mann, D. R. Wertz, J. R. Johnson, J. A. McCartney, C. E. Noble, B. C. Noble, Joe Carrieri, M. J. Vinglas, T. G. Vinglas, R. J. Conway, J. Blackburn, Frank Austin, Fred Ellis, K. W. Hainley, F. A. Gerhart, J. D. Ickes, F. A. Damico, and last but not least, A. Raymond Goodman, Karl King, John Kazmaier, and Randall Cooley.

INTRODUCTION

Horseshoe Curve can mean many things to many people, but, invariably, it is primarily associated with the coming of the Pennsylvania Railroad (PRR) and the origination of Altoona. As Altoona and the PRR developed as a major railroad center, known and respected worldwide for its research, testing, and development of all things railroad, especially motive power of the PRR's own design, the PRR became known as the "Standard Railroad of the World." All this is associated with nearby Horseshoe Curve, and since it was the first horseshoe curve ever constructed, a design of J. Edgar Thomson, chief engineer (later president of the PRR), it set the standard that enabled railroads everywhere to cross mountain ranges, which was a feat of no small importance. Horseshoe Curve's design may seem elementary within civil engineering disciplines of the 21st century (slicing mountain ledges, filling in valleys, bridging streams and roadways), since it is the same principle employed in the construction of interstate highway systems everywhere.

Horseshoe Curve near Altoona is remarkable in that this original design, and this original route, laid out by the PRR, has not had a day off, or a route change, since its conception in the 1850s. Opened on February 15, 1854, obviously in the middle of winter, one can only imagine the harsh operating conditions—not only due to weather but the technology of the day. Mechanical hand-braking systems, requiring brakemen to move from car to car under those harsh circumstances, convey images of a hazardous occupation. Altoona historian John Conlon recounts these examples from his research: "Passenger Train No. 14, the Gotham Limited, smashed into a derailed freight train on the curve, scalding to death the engineer and fireman on the passenger engine." Also, "On a rainy winter night, two trainmen were struck and killed while 'walking' their train. . . . A conductor was crushed to death in his caboose when a pusher engine, while attempting to re-couple the train, telescoped the caboose." Further, "On a July night at 3:30 a.m., as a coal train rounded the curve, the front brakeman started over the train to apply hand brakes. Jumping from car to car, he failed to notice that the car he jumped to was empty. The hopper had opened and the contents of the car had run out. One can only imagine the shock and fear he must have experienced as he slid down the slope of the empty hopper." Conlon's research continued with many other examples, including boys who unsuccessfully tried to hop aboard passing trains with tragic results. Retired locomotive engineer William Haxel of Altoona operated the largest and best of the PRR trains and locomotives on the mountain (Pittsburgh Division) such as the Pennsy's class T-1. He noted that he "wasn't afraid of the mountain, but he always respected it." Operating conditions, especially weather, on the mountain west of Altoona via Horseshoe Curve were unique and unlike any other section of the railroad between Philadelphia and Pittsburgh. Dry weather in Altoona could change to pounding rain or driving snow at the 12-mile mark passing Gallitzin summit, which is also the eastern continental divide. Before mechanization, the right-of-way, this "broad way" four-track

main line, was maintained by legions of track workers, using hand tools, and track-walkers, who inspected every mile in the era when rail lengths were 39 feet in length and bolted together with splice bars.

Horseshoe Curve to most people, though, is a very scenic tourist destination. Most see this grand landscape during daylight hours and under pristine conditions in their favorite seasons. But serious are the operations of this railroad, even as the decades have passed and the technology changes. Railroad operations are much safer in this 21st century. Equipment and infrastructure improvements have addressed every conceivable issue, and safety training for the train crews has helped considerably. The casual tourist and railfan alike should understand that trespassing on the right-of-way is not only a serious offense but also extremely dangerous.

The PRR, as a corporate entity, is obviously credited with selection of this route, most unusual for its day, and for forging a system that linked east and west that still serves this country's needs into the 21st century. The PRR operated this system from 1846 to 1968 and thus deserves the lion's share of this history, for it developed and laid the foundation for future generations. While the Penn Central merger was short-lived, its successors have carried the banner forward with success, much to their credit. Volumes are yet to be written in Horseshoe Curve's history for we know not what the future holds. The corporate mergers of the future will no doubt have much impact, but the history developed thus far has been written and cannot be taken away. The corporations that continue have a stewardship to perform while further developing the industries it serves. We await the next chapter.

As the 21st century proceeds, Horseshoe Curve continues to draw thousands annually, but the once expansive vista of this landscape needs help. Maturing tree growth, often retarded in the steam era with cinder accumulation and the occasional forest fire, is diminishing the view year by year. We hope for the day when officials of the railroad, the Commonwealth of Pennsylvania, and the City of Altoona watershed can address a forestry management program that will continue to enhance this national historic site for future generations to enjoy, while conserving the natural resources that abound. This national historic landmark deserves no less. Author Dennis P. McIlnay sums it up appropriately: "To me, Horseshoe Curve is neither a canyon nor a curve. It is a cathedral."

Additional sources of information for this book are as follows: *Westsylvania Magazine*; *A Field Guide to Trains of North America*; *Allegheny Passage: An Illustrated History of Blair County*; *Altoona Mirror*; *Altoona and the Pennsylvania Railroad: Between a Roar and a Whimper*; *Altoona Charter Centennial 1868–1968*; **Altoona Centennial Booklet of 1949**; *Blair County's First Hundred Years 1846–1946*; *Crossroads of Commerce*; *Centennial History of the Pennsylvania Railroad Company 1846–1946*; *History of the Pennsylvania Railroad Company*; *Horseshoe Curve: 125 Years*; *Horseshoe Curve: Sabotage and Subversion in the Railroad City*; *Horseshoe Heritage: The Story of a Great Railroad Landmark*; *Pennsy Power I*; *Pennsy Power II*; *Pennsylvania Railroad's Broadway Limited*; *Railfan's Guide to Horseshoe Curve*; *Railpace Newsmagazine*; *The Growth and Development of the Pennsylvania Railroad Company 1846–1926*; *Mutual Magazine*; *PENNSY* magazine; the Railroad Press (TRP); *TRAINS* magazine; *Traveling the Pennsylvania Railroad: The Photographs of William H. Rau*; *Two Generations on the Allegheny Portage Railroad*; *World Famous Horseshoe Curve*; *Triumph I—Altoona to Pitcairn*; *Eldorado Saga*; and *The Kittanning Trail*.

One

ALLEGHENY PORTAGE RAILROAD

Before the advent of the Pennsylvania Railroad (PRR), around 1846, the Allegheny Portage Railroad (APRR) was the only means of crossing the Allegheny Mountain range west of Hollidaysburg other than by foot, horseback, or horse-drawn wagon, an arduous journey. APRR was a segment of the Main Line of Public Works, a cross-state canal system that ended at the Hollidaysburg Canal Basin on the east side of the mountains or Johnstown on the west. Between these two points, an inclined plane system moved the canal boats over the Allegheny Mountain range on railroad flatcars. Early steam locomotives of the day conveyed the boats on flatcars on level terrain, but a series of stationary steam engines pulled the boats on rail carriages over the Allegheny Mountains from either the east or west and simultaneously lowered canal boats on flatcars in a similar fashion to balance the load, using ropes and cables. However, since the APRR was connected to the Main Line of Public Works canal system, operations ceased in the winter months when the canals froze over. Also, the system did not operate at night. Although this system only lasted approximately 20 years, it revolutionized travel between Philadelphia and Pittsburgh, a journey of three and a half days. However, even in good weather the route was slow and ponderous, providing an incentive to seek improvements. Too little and too late, the APRR tried to engineer an improved "New Portage Railroad" to bypass the inclined planes. The 20th anniversary of the portage railroad was observed without fanfare in March 1854, just one month after the relatively new PRR opened its all-rail, all-locomotive railroad over the Allegheny Mountains on a competing route. The PRR, incorporated just a few years prior in 1846, had also been a major shipper on the canal and APRR as its line interchanged with it at Duncansville. The opening of the PRR railroad line over the mountains via its engineering achievement, Horseshoe Curve, revolutionized rail travel and cut the travel time dramatically, essentially putting the Main Line of Public Works and APRR out of business. In a few short years, the PRR would purchase the canal/portage railroad systems from the Commonwealth of Pennsylvania for a fraction of the APRR's former worth.

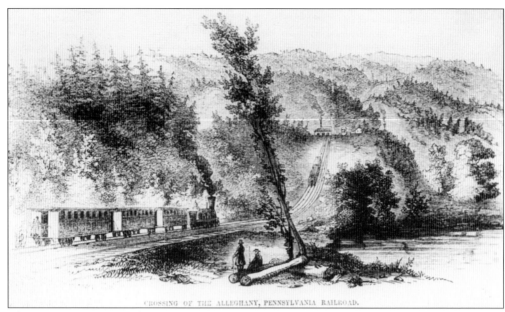

CROSSING OF THE ALLEGHANY, PENNSYLVANIA RAILROAD.

The APRR is shown in this view, as a train approaches the Allegheny Mountain range on the level, pulled by a vintage steam locomotive of 1830s design, to be transferred to the inclined-plane rope/pulley system, powered by stationary steam engines. Three-inch Russian hemp rope was later replaced by wire rope invented by Pennsylvania native John Roebling, whose cables were also used in the construction of the Brooklyn Bridge. (Author's collection.)

Incline plane No. 6, view east from the summit, descends toward Blair Gap Run and Hollidaysburg. This site is now maintained by the National Park Service. In this view, plane No. 6 has been re-created to match its original design. The severe grades and slow pace contributed to the demise of the road after a short life span of 20 years, and the success of the PRR's new Horseshoe Curve route rendered the railroad obsolete. (Author's collection.)

The reconstructed engine house at Summit, cresting the Allegheny Mountains at 2,314 feet, is midway between the east and west slopes of the Allegheny Mountains. Canal boats were pulled or lowered on rail carriages. Initially, three-inch Russian hemp rope was utilized until the invention of wire rope by Pennsylvania native John Roebling, which reduced accidents significantly. (Author's collection.)

This is an easterly view of the summit toward the reconstructed engine house for plane No. 6 on the APRR. Rails are affixed not to wooden railroad ties but to stone sleepers, large hand-cut square blocks of native sandstone countersunk in the soil and hand-drilled with holes to accommodate large screws that affixed the rail to the sleeper. (Author's collection.)

Since travel on the APRR was slow and ponderous at best, matching the slow pace of the canal system it interchanged with, Summit was a major rest stop for weary travelers. The Lemon House Tavern (operated by Samuel Lemon and his family) provided food and beverages, as well as lodging, although primitive by today's standards. Charles Dickens was one of the system's noted travelers. (Author's collection.)

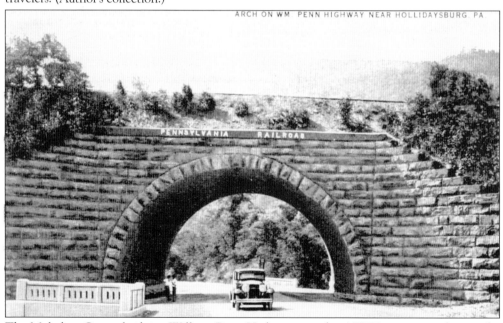

The Muleshoe Curve, bridging William Penn Highway, was the APRR's attempt to bypass the inclined plane system on the New Portage Railroad to expedite travel, but it was too little, too late as the new competitor, the PRR, siphoned away most traffic, essentially putting the APRR out of business. This postcard view was hand-canceled on November 22, 1931, on an "N.Y.-Pittsburgh" railway post office car on PRR train No. 18. (Author's collection.)

Two

PENNSYLVANIA RAILROAD

Known worldwide for the engineering achievement of J. Edgar Thomson, chief engineer of the new PRR (1846), Horseshoe Curve, the region's most visible landmark, has become synonymous with Altoona, which was also founded and named by the PRR. The valley floor that became Altoona grew first as a staging facility for construction of the railroad westward, then as a maintenance facility, evolving into major shops for manufacturing locomotives and cars. Altoona was populated heavily by immigrants seeking work, particularly Irish, German, Italian, and Polish with other ethnic groups in lower numbers. There was a British presence, particularly among management, as steam technology emerged from British influences in the 1830s. Each ethnic group offered particular talents and abilities. Significant in this regard, the mountain railroad west of Altoona, especially the Horseshoe Curve, was constructed by a force of approximately 450 Irish laborers from County Cork, Ireland. Using picks, shovels, handcarts, mules, wheelbarrows, and black powder, that mountain terrain was tamed during the three-year construction period from 1851 to 1853 under Thomas Seabrook, construction superintendent (Horseshoe Curve and Gallitzin Tunnel.) Paramount among these talents was the strong work ethic that existed among the Irish and other culturally diverse groups. Many of the Irish immigrated to the United States and Canada to find work, escaping the potato famine that was impacting Ireland around the same time.

The growth of Altoona paralleled the growth of the PRR, *the* singular primary industry of the region. Accordingly, many ethnic neighborhoods were established within the city. Of particular note, Altoona went from farmland to 75,000 people in 75 years—all attributable to the arrival and growth of the PRR. The success of the railroad, linking eastern and western markets, created jobs as Altoona became a focal point of the expanding PRR system. However, the steam era would finally end in 1957, a slide that began in the early 1950s following World War II, resulting in massive unemployment for the city, impacting the railroad workers who built, maintained, and operated these machines that enabled the industrial age in America to blossom and succeed. The impact on Altoona was more significant than anywhere else, as the highly trained craftsmen and their skills were no longer needed and other industry was not yet diversified. The PRR too would pass from the roster on February 1, 1968, when it merged with rival New York Central Railroad. Through all this history that personifies the PRR, and Altoona, Horseshoe Curve has endured and continues to serve as that singular vital link that enabled railroads everywhere to conquer geographical obstacles, serving the growth and development of these United States.

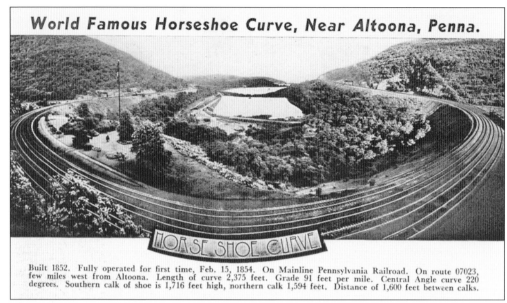

World Famous Horseshoe Curve, Near Altoona, Penna.

Built 1852. Fully operated for first time, Feb. 15, 1854. On Mainline Pennsylvania Railroad. On route 07023, few miles west from Altoona. Length of curve 2,375 feet. Grade 91 feet per mile. Central Angle curve 220 degrees. Southern calk of shoe is 1,716 feet high, northern calk 1,594 feet. Distance of 1,600 feet between calks.

The Horseshoe Curve is indeed world famous. As the first horseshoe curve, this revolutionary engineering enabled the PRR, and others, to climb mountains. As this card proclaims, the length of the curve is 2,375 feet, with a grade of 91 feet per mile. The central angle of the curve is 220 degrees. The southern calk of the curve is 1,716 feet high, northern calk 1,594 feet, with a distance of 1,600 feet between calks. (Author's collection.)

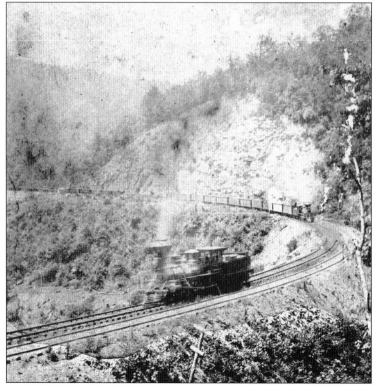

This early stereo-view card of Horseshoe Curve around the 19th century shows an eastbound locomotive and a passenger train following on a two-track curve. These early locomotives were common during the Civil War era. The slice on the face of Kittanning Point, and the entire mountain route, was accomplished over a four-year period by 450 Irish laborers utilizing picks, shovels, mules, wheelbarrows, and black powder. (Courtesy of Elaine Conrad.)

...ereo-view card from
...1 the 19th century
...the great fill as
...tbound passenger
...escends around
...hoe Curve toward
...na. The great fill was
...ed by excavations of
...ning Point, named
...Kittanning Indian
...hat passed through
...ea. Although an
...ntary method of
...ngineering today,
...hoe Curve was
...st such design and
...ed construction
...ds for railroads and
...ays from that time
...d. (Courtesy of
...Conrad.)

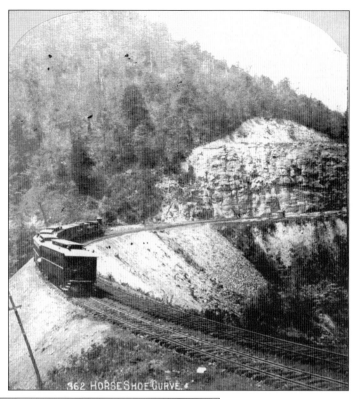

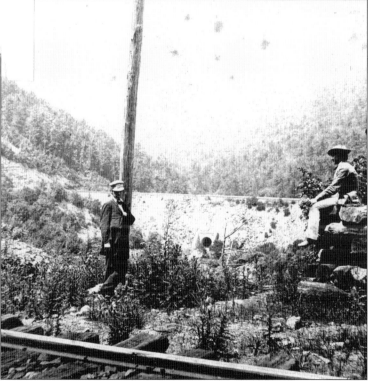

"The Picturesque
on the Pennsylvania
Central RR—On
the high grade above
Altoona looking
across Kittanning
Point" is illustrated
on this stereo-view
card dating from
around 1904. Two
men are depicted
admiring the scenery
on the western
elevation of the
Horseshoe Curve.
In these early views,
the landscape is
spectacular and
unencumbered by
mature vegetation
and foliage. (Courtesy
of Elaine Conrad.)

15

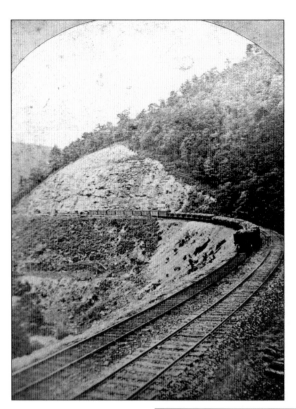

This is an early stereo-view card of Horseshoe Curve looking west to the apex from the eastern ledge, showing a westbound freight train on the then two-track main line during the 19th century. In a few short years, efforts would continue to engineer Horseshoe Curve into a four-track main line, a necessity to handle the constantly expanding passenger and freight traffic demands on this railroad line that connected eastern and western markets. (Courtesy of Elaine Conrad.)

Pictured here is a c. 1900 stereo view of the bowl of Horseshoe Curve. In this view, Horseshoe Curve has a four-track main line. In the background are three recently constructed reservoirs for the city of Altoona that cover the valley floor of the Horseshoe Curve bowl. The outcropping of soil in the lower right would become Horseshoe Curve Park, which has attracted visitors since the line's construction. (Courtesy of Elaine Conrad.)

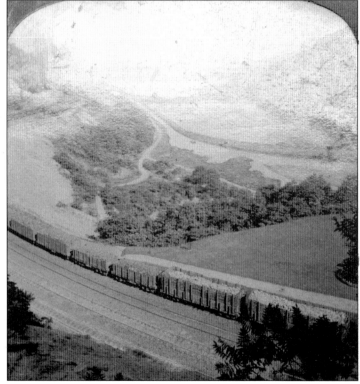

This is a stereo-view card, paraphrased, proclaiming, You are on the west side of this famous curve, one of the best pieces of railroad construction in the country. The train is westbound heading nearly southeast to cross the Alleghenies. Only five miles west of here as the crow flies (twice as far by track), the road descends out of the mountains to Pittsburgh, 80 miles to the west. (Courtesy of Elaine Conrad.)

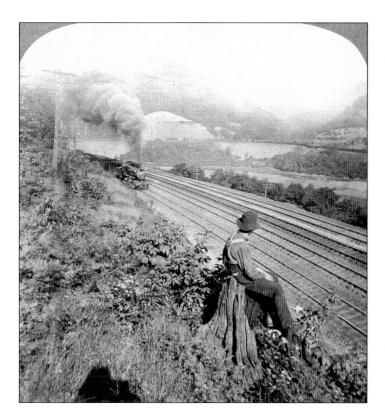

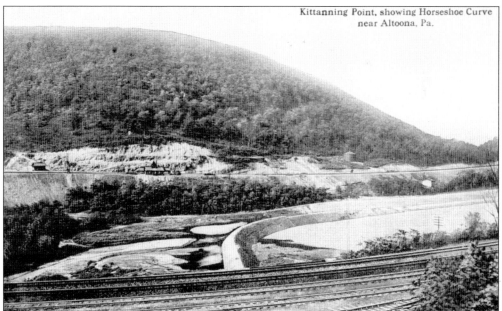

This *c.* 1915 view is from the west side to the east side and the Kittanning Point station. The apex of Horseshoe Curve would be to the left out of view. In the foreground, a spur line may be seen, which led to Glen White Coal Mine and a series of beehive coke ovens nearby, all of which no longer exist today except the coke oven ruins. (Author's collection.)

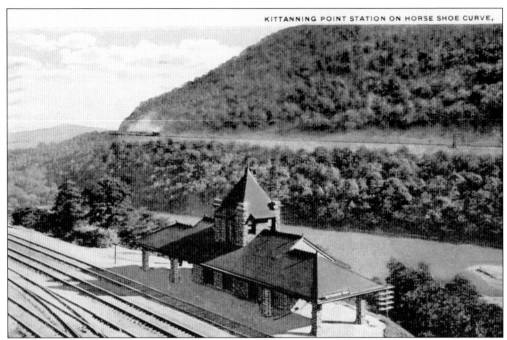

This *c.* 1920 postcard view clearly illustrates the Kittanning Point station on the east side of Horseshoe Curve. In the distance may be seen an eastbound train descending the Allegheny Mountain range toward Horseshoe Curve. The Kittanning Point station was razed just prior to World War II. (Author's collection.)

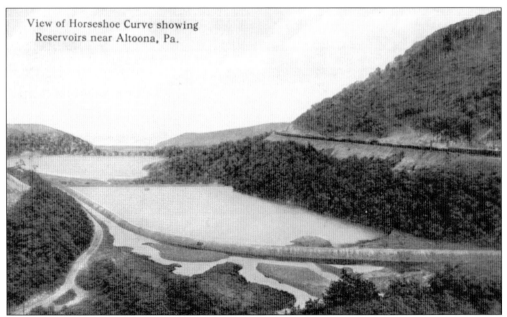

View of Horseshoe Curve showing Reservoirs near Altoona, Pa.

In this *c.* 1915 postal card view may be seen the impressive water reservoir system for the city of Altoona, a series of three dams in succession in descending order by elevation, from the apex of Horseshoe Curve. (Author's collection.)

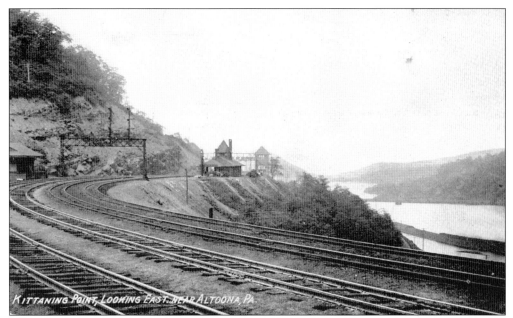

This is a vintage postcard view of the Kittanning Point station from near center of Horseshoe Curve looking east in the early 1900s. A small freight station is at the immediate left, and a branch line spur entered a narrow valley for coal mine access. Another spur track, on the ledge of the hillside slightly above the top level of the signal bridge, supplied coal to a locomotive coal tipple just beyond the Kittanning Point station. (Author's collection.)

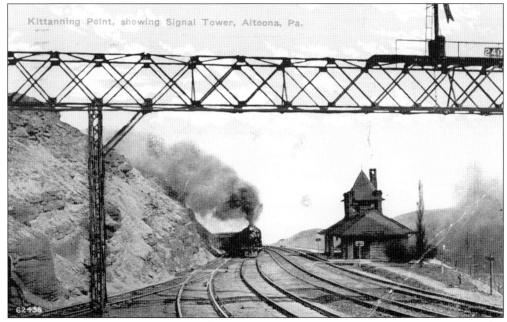

In this postcard view canceled in 1913, a westbound train is approaching Horseshoe Curve and is about to pass the Kittanning Point station. The signal bridge displays vintage semaphore signals for eastbound traffic only. The spur line to the immediate left serviced coal mines in a narrow valley. (Author's collection.)

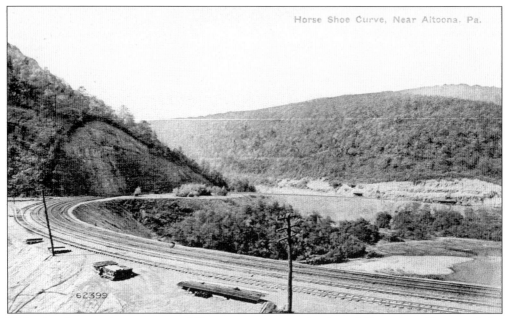

62399

This view from a vintage postcard illustrates a panoramic view of Horseshoe Curve and the face of Kittanning Point Mountain. The aggregate from the excavation of Kittanning Point Mountain was used as fill to bridge streams on each side of the apex and a road. A numerical legend on this card would seem to indicate this view of a four-track main line on Horseshoe Curve to be taken on June 23, 1899. (Author's collection.)

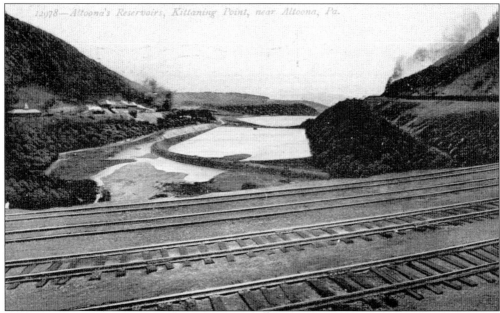

12078—Altoona's Reservoirs, Kittanning Point, near Altoona, Pa.

A postcard view, canceled in Juniata on June 24, 1907, shows a four-track main line and Altoona's reservoir system. The Kittanning Point station is on the left (east) side of the curve. Juniata, formerly, was a separate borough but was annexed into the city of Altoona and was home to the PRR's locomotive shops, still retaining that status under the Norfolk Southern Railroad in the early 21st century. (Author's collection.)

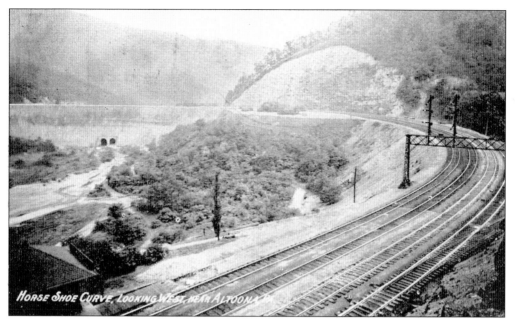

Here is a panoramic view of Horseshoe Curve from the area near the Kittanning Point station on a postal card view canceled in 1913. The massive fill is clearly indicated in this view, and the culverts carry Glen White Run and a roadway to Glen White Coal Mine and village, above Horseshoe Curve. The village and mine are long gone and only ruins of beehive coke ovens remain in the early 21st century. (Author's collection.)

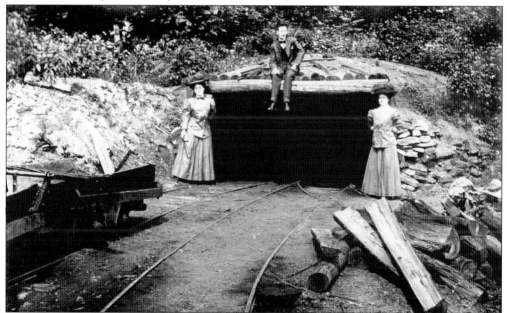

This is a vintage photograph of the Glen White mine. One must presume this is a Sunday due to the man and women being in "Sunday" dress clothes. It is also presumed that the man works at the mine, which was located in a narrow valley off the west side of Horseshoe Curve's apex. The Glen White mining camp was located nearby along Glen White Run, and beehive coke ovens were also in the vicinity. (Author's collection.)

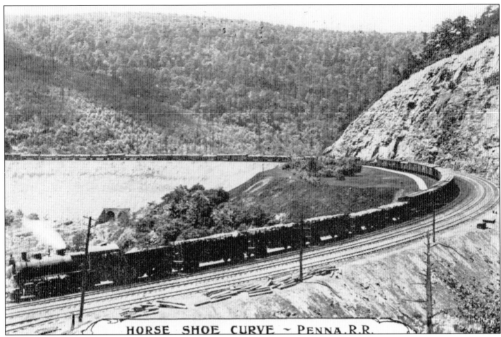

An eastbound mixed-freight train descends Horseshoe Curve in this postcard view canceled in September 1911. The steam locomotive is of a later design and heavier construction utilizing the PRR signature Belpaire Firebox design (squared-off at the rear of the boiler and forward of the cab). This is possibly an R class locomotive. (Author's collection.)

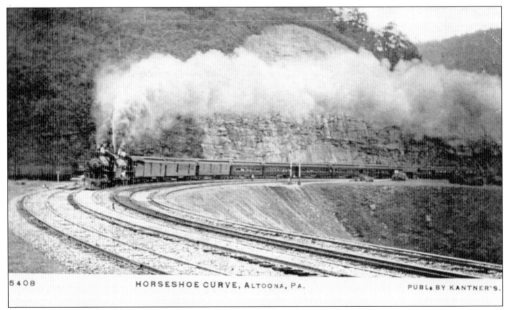

This is an early-20th-century view of a double-headed (two steam locomotives) passenger train westbound on Horseshoe Curve. Westbound trains worked hardest on the curve, and passenger trains often had extra locomotives on the front while freight trains often had locomotive assists at the rear of the train. (Author's collection.)

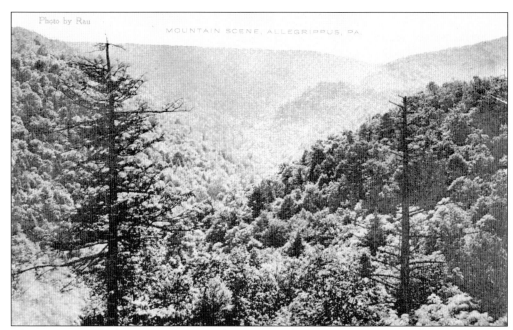

This is a postcard adaptation of a scenic location at Allegrippus, west of Horseshoe Curve. This view is attributed to William Herman Rau, who was employed by the PRR to photograph the system to promote travel. (Author's collection.)

Pictured here is a postcard view from an H. C. White stereo view, around 1907, from the Weichert-Isselhardt Collection via "Images from the Past." The clarity of this view is remarkable, and it is a westerly view toward Kittanning Point Mountain as this eastbound passenger train passes the semaphore signal bridge near the Kittanning Point station. The spur to the right services a nearby coal mine. (Author's collection.)

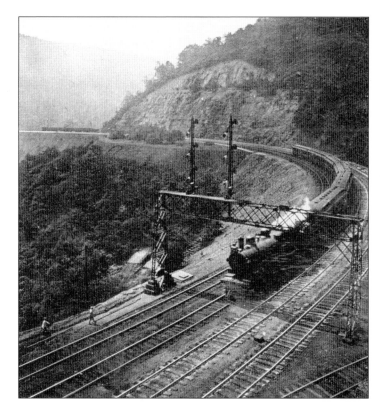

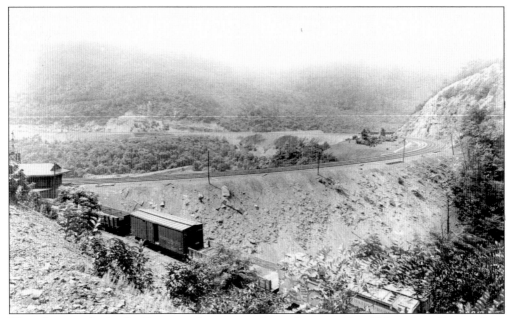

This photograph clearly illustrates the spur track on the east side of Horseshoe Curve where it junctions with the main line. Kittanning Point Mountain is at the extreme right, and the Kittanning Point freight station is at the left edge with the semaphore signal bridge adjacent. The great fill approach to the Horseshoe Curve apex is recently expanded to accommodate a four-track railroad as new vegetation growth is absent. (Courtesy of Andy Mulhollen.)

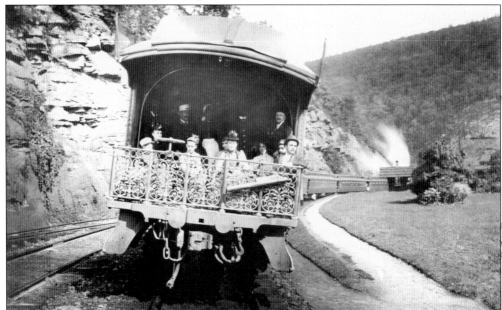

In this late-19th-century view, the eastbound *Pennsylvania Limited* pauses on Horseshoe Curve for a portrait by famed photographer William Herman Rau (January 19, 1855–November 19, 1920). Rau was commissioned by the PRR in the 1890s to photograph its system, resulting in approximately 450 images on glass-plate negatives finished in an albumen process. (Courtesy of Railroader's Memorial Museum.)

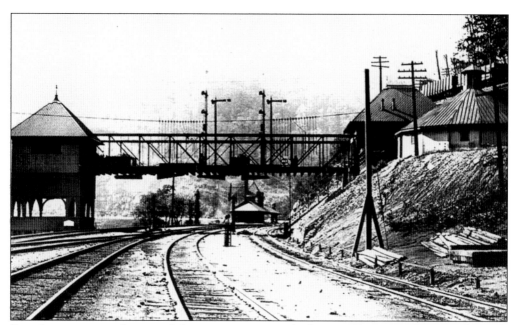

Seen here is a westerly view of the engine servicing facilities at Kittanning Point in the early 1900s. Trains would stop here for coal and water, but it was often difficult to start westbound trains due to the grade, depending on the total weight of the train and number of cars. Locomotive development in the third and fourth decades of the 20th century enabled trains with new motive power to bypass this stop. (Courtesy of Railroader's Memorial Museum.)

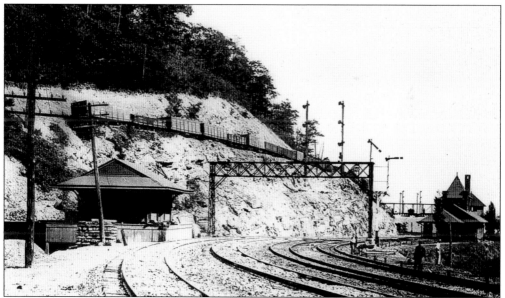

This view of the east side of Horseshoe Curve shows the Kittanning Point freight station (left) and the Kittanning Point passenger station (right). The elevated spur track carries coal to the engine servicing bridge in the distance. Period semaphore signals pierce the horizon. The industry at this locale is in stark contrast to the 21st-century scenes (see the Conrail and Norfolk Southern Railroad chapters), which display only a modern signal bridge. (Courtesy of Railroader's Memorial Museum.)

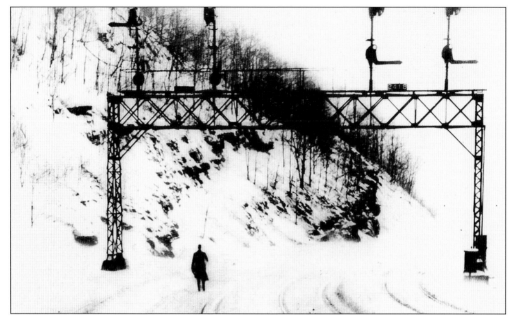

In this image dated January 24, 1936 (just three months prior to the St. Patrick's Day floods of 1936, which would devastate the PRR system), a brakeman is seen protecting the rear of his stopped train on Horseshoe Curve. Lumps of coal litter the snow, no doubt from passing coal trains and locomotive tenders. In Depression years, people walked along the railroad to pick up lumps of coal to heat their homes. (Courtesy of Railroader's Memorial Museum.)

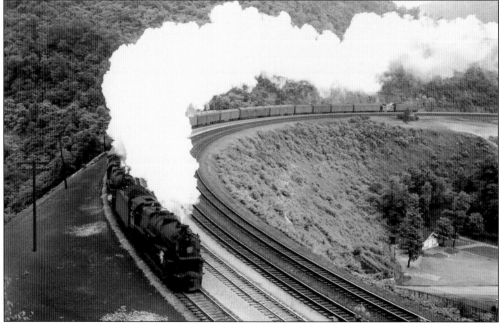

This is a spectacular elevated view of Horseshoe Curve from the west side, showing an express-mail train westbound, with double-headed K-4 class Pacifics providing fast transport for the nation's mail. A caboose trails this consist, with another express car behind, possibly added at Altoona. (Courtesy of Norfolk Southern Corporation via Railroader's Memorial Museum.)

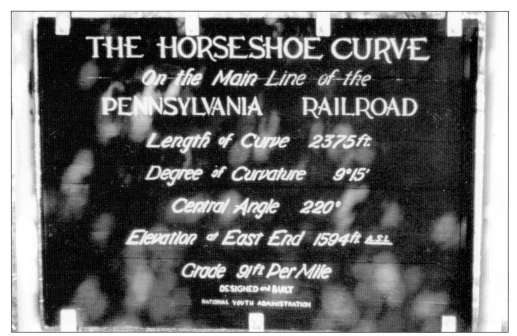

Here is one side of a hand-carved sign posted at Horseshoe Curve for over 60 years made by the National Youth Administration (a New Deal agency from the Depression years and operated from 1935 to 1943 as part of the Works Progress Administration), describing the engineering data that applies to the design of Horseshoe Curve. (Author's collection.)

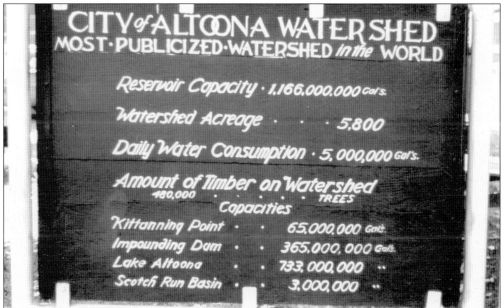

This is the obverse side of a hand-carved sign posted at Horseshoe Curve for over 60 years, which describes the pre-1980 capacities of the three reservoirs that are located in the bowl of Horseshoe Curve. In later years, the capacities were expanded with the addition of inflatable fabri-dams on the spillways as well as reconstructing the dam breastworks to meet 21st-century standards, and a water filtration plant was also added to the system. (Author's collection.)

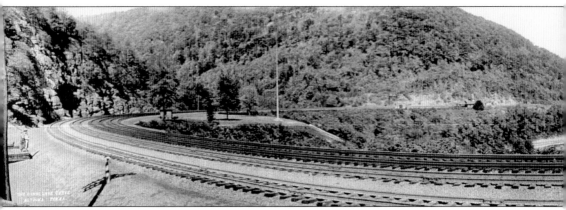

This well-executed panoramic view of the PRR's well-maintained four-track Horseshoe Curve was taken by A. P. McDowell on October 12, 1934. The broad four-track main line was also the

This is a popular dual postcard of Horseshoe Curve from around the 1930s that was commonly

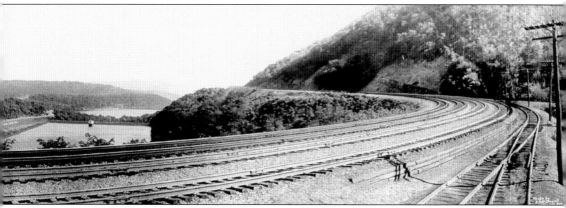

namesake of the road's premier all–sleeping car train, the *Broadway Limited*, which traversed this route daily in its eastbound and westbound journey. (Courtesy of Library of Congress.)

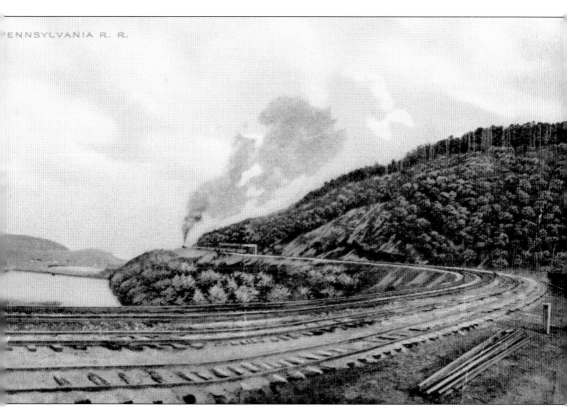

PENNSYLVANIA R. R.

found in area drugstores and commercial outlets at the time. (Author's collection.)

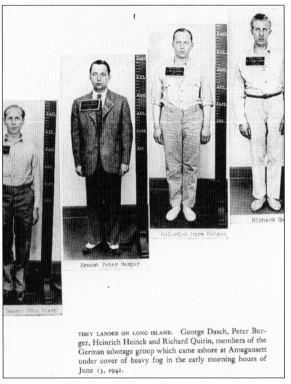

THEY LANDED ON LONG ISLAND. George Dasch, Peter Burger, Heinrich Heinck and Richard Quirin, members of the German sabotage group which came ashore at Amagansett under cover of heavy fog in the early morning hours of June 13, 1942.

The Horseshoe Curve became a designated target-of-intent during World War II when four German saboteurs, George Dasch, Peter Burger, Heinrich Heinck, and Richard Quirin, landed on Long Island on June 13, 1942, and four additional men, Edward Kerling, Werner Thiel, Herbert Hans Haupt, and Hermann Neubauer, landed near Ponte Vedra, Florida, for the same purpose. All had previously been in the United States during the Depression years and, unable to find work, returned to Germany only to be recruited under duress for this mission. Leader George Dasch went to the FBI and the plot was revealed and thwarted, resulting in arrest, and execution for six of the eight because it was a time of war. This was a precedent-setting case used in 2006–2007 for military tribunal detainment/incarceration of terrorists. (Courtesy of Dennis P. McIlnay, Ph.D.)

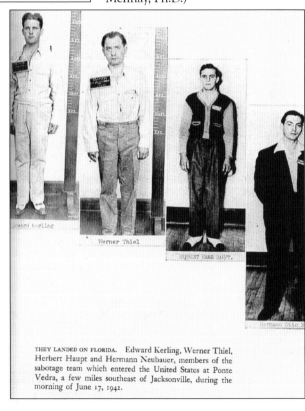

THEY LANDED ON FLORIDA. Edward Kerling, Werner Thiel, Herbert Haupt and Hermann Neubauer, members of the sabotage team which entered the United States at Ponte Vedra, a few miles southeast of Jacksonville, during the morning of June 17, 1942.

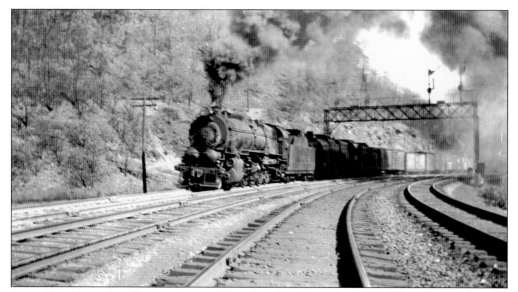

A westbound merchandise train enters Horseshoe Curve on November 15, 1935, passing under the semaphored signal bridge near where the Kittanning Point passenger and freight stations once stood. Headed by a class I-1 locomotive, this is a double-headed train, meaning there are two locomotives on the head end. In all probability, helper locomotives would also be on the rear of the train assisting with the climb to the Allegheny summit. (Courtesy of Paul W. Westbrook Jr.)

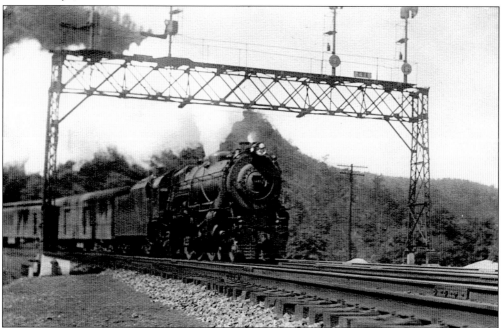

Taken from a colorized print, an eastbound passenger train passes under the same semaphore signal bridge eastbound toward Altoona. This consist is headed by a class K-4 Pacific, equipped with 80-inch driver wheels, which enabled this class of passenger locomotive to achieve high speeds with quick starts. This locomotive is equipped with its original slatted pilot under the coupler, a marked difference from post-1938 streamlining modernizations. (Author's collection.)

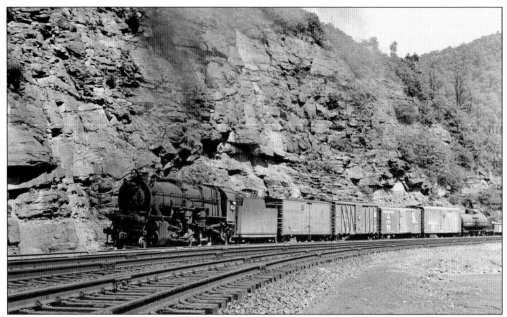

Pictured is a westbound merchandise consist with a class I-1 decapod on the point. Westbound trains had many empties—cars returning from eastern markets. While the tonnage of this train is not known, the use of one locomotive would give credence to this concept, although helpers may be on the rear. Most of the company logos on the freight cars pictured are now fallen flags in the industry. (Courtesy of Bob Lorenz.)

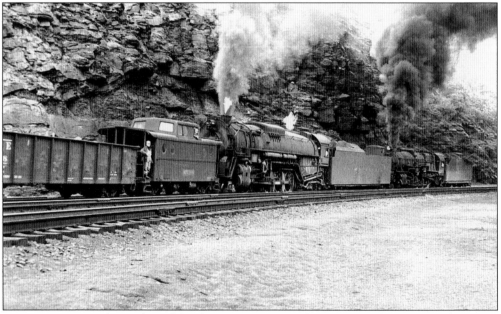

Here is a rear view of a westbound freight consist on Horseshoe Curve in the 1940s. A class N-5C (porthole) caboose (cabin in PRR terms) is on the rear with two powerful locomotives pushing the train westbound. The lead locomotive against the cabin is a World War II–era massive class J-1 Texas type, and the last locomotive is probably a class I-1, indicating this is a very heavy train trying to cross the eastern continental divide at Gallitzin summit. (Author's collection.)

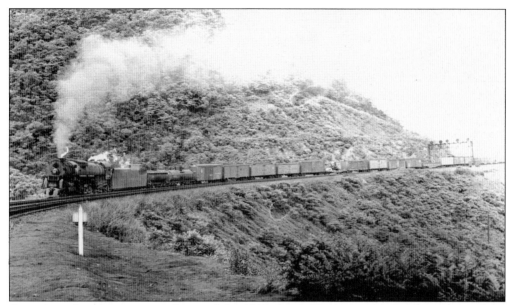

A westbound consist is pictured around the 1940s headed by a class J-1 Texas type, one of the largest of the World War II era to carry the nation's freight and defense shipments. The wheel arrangement on the massive locomotive is 2-10-4, and it could out-haul older classes of I-1s and M-1s and was well suited to mountain terrain. These locomotives were also characterized by their long-distance tenders, which provided expanded capacity for water and coal. (Courtesy of Trackside Photo.)

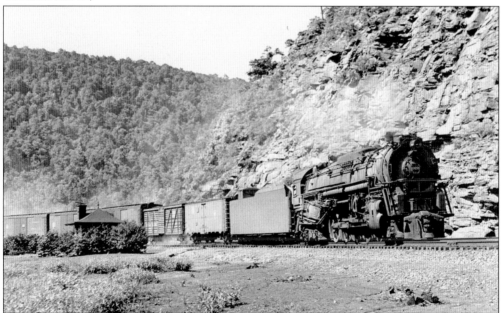

An eastbound freight consist passes the apex of Horseshoe Curve in the late 1940s, headed by J-1 Texas type No. 6405. Horseshoe Curve Park (left) has seen little maintenance over the war years, but the railroad is still characterized by a four-track main line. Since Horseshoe Curve was off-limits during World War II, this view is believed to be post–World War II. In this view, the fireman waves to the photographer. (Courtesy of Bob Lorenz.)

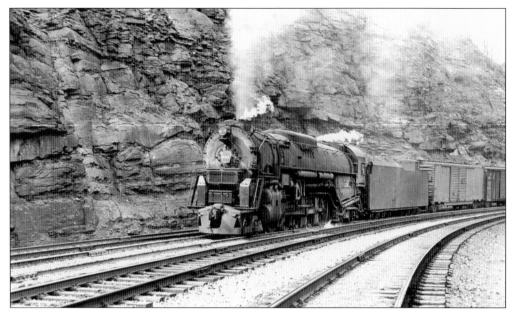

A westbound train on No. 3 track is headed by class J-1 Texas type No. 6444. The photographer (unknown) is perilously close to the railroad, a practice that would not be tolerated in the 21st century. In this view, the class J-1 appears to be handling its consist with minimum smoke, but the grade will increase significantly in about 500 feet. This scene is believed to be post–World War II. (Author's collection.)

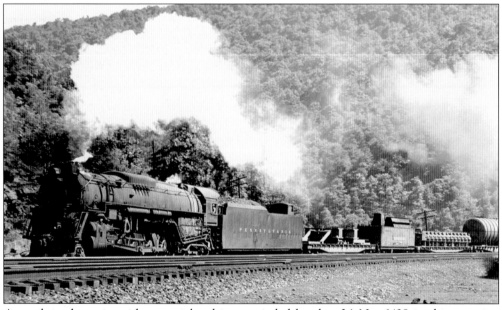

A westbound consist with a specialty shipment is led by class J-1 No. 6438 in this morning view during the late 1940s or early 1950s. This consist passed through the massive Altoona classification yard five miles previous, moving from the Middle Division onto the Pittsburgh Division. During the World War II era, the line handled approximately 54 passenger trains daily and the heavy volume of World War II freight traffic, maintaining schedules. (Courtesy of Bob Lorenz.)

An eastbound freight train descends the Allegheny Mountain range on No. 2 track into Horseshoe Curve in this 1940s scene led by an M-1 class locomotive, which was equally suited to passenger or freight service. The train has just passed MG Tower less than two miles previous and will be in the Altoona classification yard in approximately six miles, leaving the Pittsburgh Division at Slope Tower for the Middle Division. (Author's collection.)

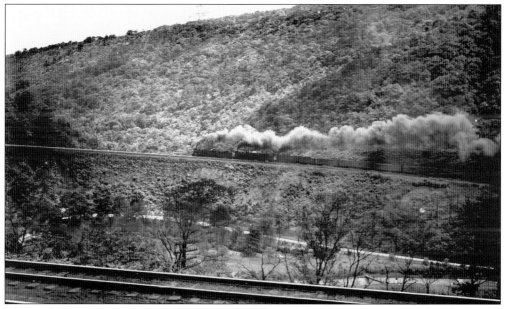

This real-photo postcard, made by Bruce D. Falls on July 25, 1948, captures a triple-headed train westbound at Horseshoe Curve. The power appears to be a K-4 class locomotive hauling a mail and express train and may have heavyweight passenger equipment necessitating the extra locomotives. Helper locomotives on passenger trains were always coupled on the head end. None were permitted on the rear as is common for freight trains. (Author's collection.)

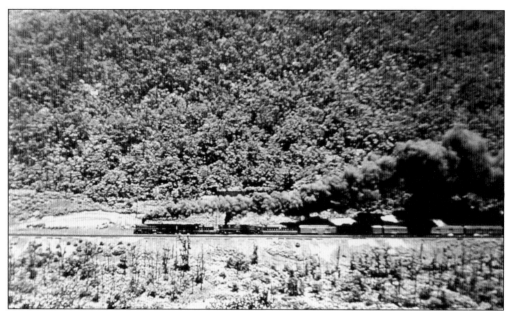

Seen here is a double-headed passenger train westbound at Horseshoe Curve around 1944–1946 powered by two of the PRR's premier locomotive design, the class T-1. These huge World War II–era steam locomotives are carrying their original paint design and lettering, making them early editions of the class. The last class T-1 locomotive was built at Altoona in 1946, but all were dropped from the roster by 1957 as the dieselization era arrived. (Courtesy of Tom Sheller.)

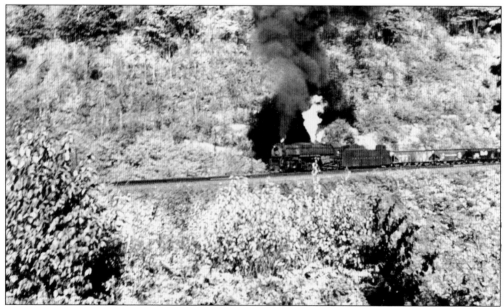

Empty hopper cars roll west into Horseshoe Curve in this 1940s scene, headed back to mines in neighboring Cambria or Indiana Counties for a refill serving industry or power plants. This consist is powered by a class J-1 Texas type, one of the larger World War II steam-era classes. The boiler has a full head of steam as evidenced by the white steam pop-off seen in back of the coal smoke. (Courtesy of Tom Sheller.)

The Horseshoe Curve, as the premier landmark associated with Altoona, was popular in many forms of advertising. In this depiction of Horseshoe Curve, a class K-4s steam locomotive and passenger train headed from Altoona to Pittsburgh and beyond graces a beer product label for the Altoona Brewing Company. This early label graced brown or green bottles of the short-neck variety. (Author's collection.)

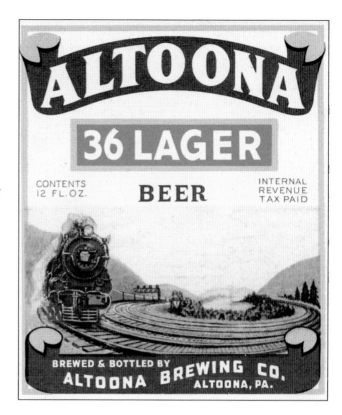

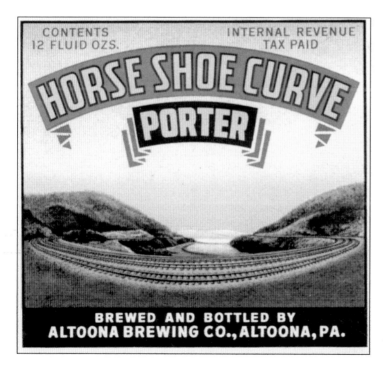

In this later beer label of the Altoona Brewing Company, the depiction of Horse Shoe Curve Porter has been changed to reflect the geographical landscape only. The brewery, in diminished form, ceased bottling in Altoona during the 1960s, but the product and label are still well known in the Greater Altoona area and were last owned by the John Kazmaier family. (Author's collection.)

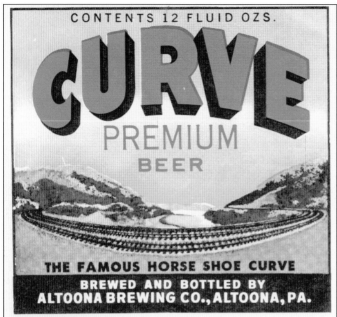

This version of the Altoona Brewing Company label, for the premium beer, has the added legend "the Famous Horse Shoe Curve." Visitors to the brewery were able to sample the product from a tap provided for that purpose. Many say the product was more popular outside the Altoona area. (Author's collection.)

The PRR acquired its first diesel-electric locomotive as early as June 1937, but dieselization did not arrive until after World War II. Baldwin model RF-16 No. 2008, built in the 1950–1952 period, enters Horseshoe Curve. Rated at 1,600 horsepower per unit, this A-B-A mix handles the task easily. The units were dubbed "sharknoses" by railroaders because of the nose design. The roofline piping was the train-phone antenna. (Courtesy of Bob Lorenz.)

Descending the east slope at Horseshoe Curve is a Baldwin class BP-60 locomotive set lead by No. 5823 powering an eastbound passenger train. These units, at 6,000 horsepower, were initially in passenger service but were later downgraded for freight service only, 5,000 horsepower. Two units are semipermanently coupled together; their multiple wheels and Westinghouse 370F traction motors earned the nickname "centipede." Many finished their time on Horseshoe Curve as helpers. (Courtesy of Bob Lorenz.)

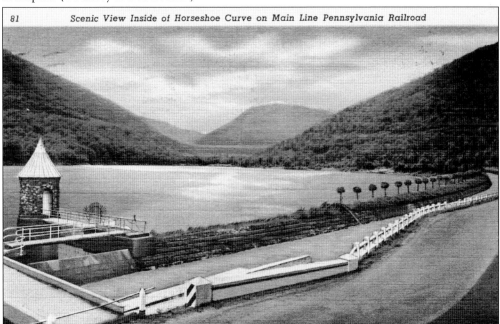

This linen postcard view illustrates, "Some of Pennsylvania's greatest natural mountain scenery awaits the motorist who views the Horseshoe Curve from the inside. Three reservoirs of the Altoona water supply are in or below the curve at an elevation of 1300 to 1500 feet." The card is postmarked July 29, 1939, with a 1¢ George Washington stamp. (Author's collection.)

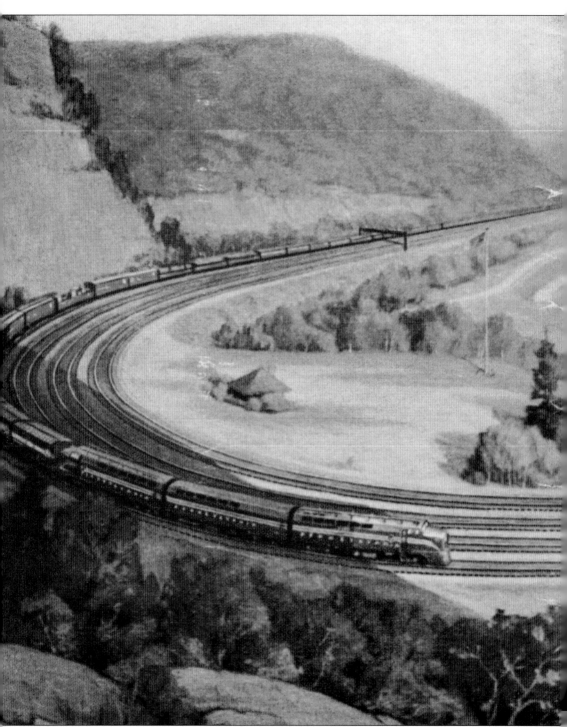

This PRR image was popularized by the art of Grif Teller (American, 1899–1993), who depicted scenes of the system that appeared on art calendars annually and other advertising materials such as this brochure, which illustrates Horseshoe Curve. The same image appeared on the 1952 calendar. Teller employed some artistic license in this scene, which results in enormous impact

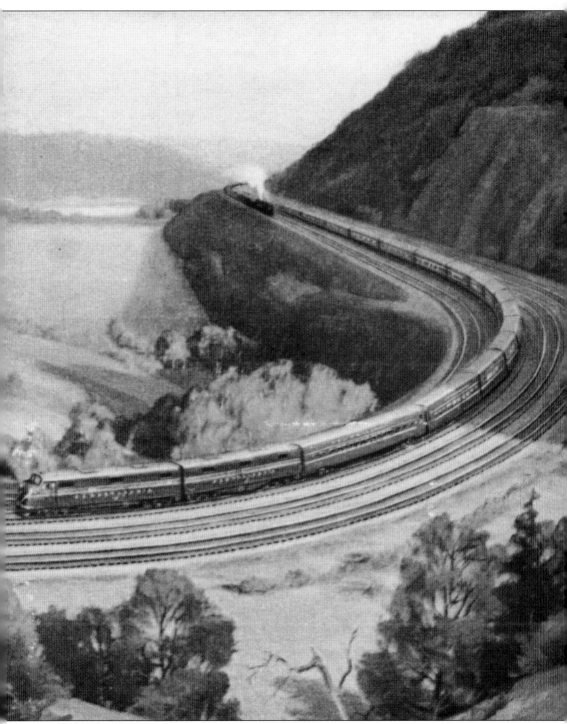

for the viewer. The image was very popular system wide, particularly in the Altoona area. An oversize reproduction graced the main lobby of an Altoona bank for many years and now hangs at Railroader's Memorial Museum. (Author's collection.)

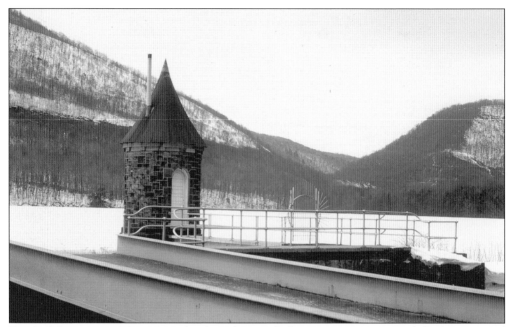

Pictured here is a 1960s view of Lake Altoona (Altoona reservoir system) looking toward Kittanning Point and Horseshoe Curve in early winter. The apex of Horseshoe Curve is at right, and the westward main line is along the snow line to the rear of the control house's peaked roof. The valley of the curve is noted for its commanding scenery in many seasons. (Author's collection.)

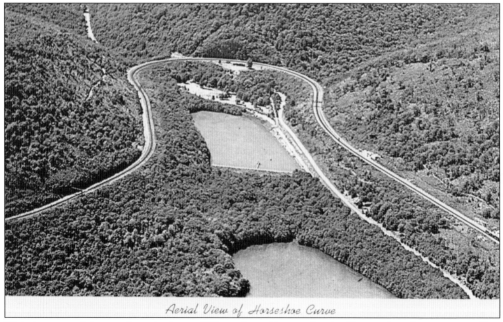

Aerial View of Horseshoe Curve

This is an aerial postal card view of Horseshoe Curve clearly illustrating the commanding geography and engineering of J. Edgar Thomson. This view differs markedly from the 1952 calendar painting by PRR calendar artist Grif Teller, which elongated the approaches to the curve. (Courtesy of Sheldon L. Burns.)

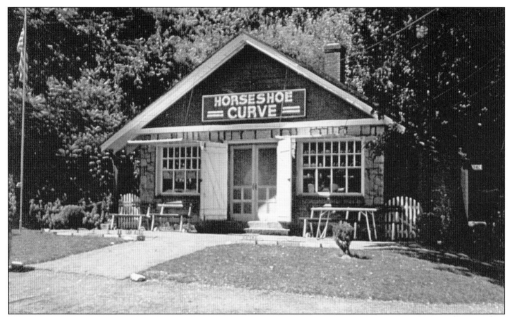

This concession building, constructed during the 1930s by the Works Progress Administration, was operated for decades by Mr. Clair E. Lockard, a highly respected and cordial resident of Altoona. On summer evenings, Clair and Florence Lockard and Mr. and Mrs. Sheldon Burns would enjoy chatting with the many visitors. Summer evenings were more enjoyable here than in the city heat of Altoona, and the sound effects and visuals were spectacular. (Author's collection.)

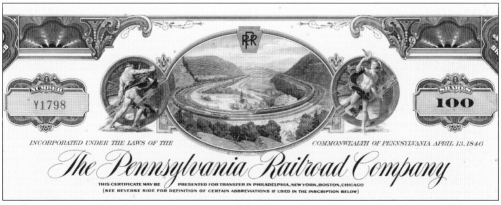

In this vignette, the elaborate engraving of the Horseshoe Curve, taken from a PRR stock certificate, can be seen. The engraving replicates the image of Horseshoe Curve as depicted on the company's 1952 art calendar from the original work of artist Grif Teller (1899–1993). This engraving graced both the preferred and common stock certificates for the PRR Company. (Author's collection.)

THE PENNSYLVANIA RAILROAD

Serving You Through Progress in Transportation

This cover from a 1950s-era publicity pamphlet published by the PRR shows a heavy freight train descending the Allegheny Ridge at Horseshoe Curve, headed for Altoona and points beyond. This train is powered by an A-B-A set of F-7 diesel-electric locomotives. As can be seen, the train trails a vapor of brake shoe smoke in its descent. On hot summer days, the smell of brake shoe smoke and creosote from the railroad ties was unique to railroad rights-of-way and well known by those who enjoyed watching train movements. (Author's collection.)

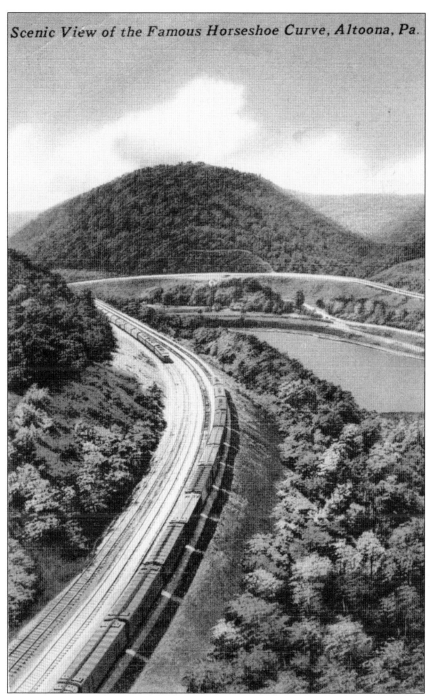

Scenic View of the Famous Horseshoe Curve, Altoona, Pa.

In this linen-style postcard from Altoona News Agency, this view of the Horseshoe Curve is seen from high on the western ridge. The postcard states, "The Horseshoe Curve is a noteworthy piece of railroad engineering on the Pennsylvania Railroad along the slopes of Allegrippus Gorge near the summit of the Allegheny Mountains. It may be seen on the left of the train, traveling westward just beyond Altoona, Penna., and with a graceful curve of 1845 ft. nearly 1600 ft above the sea, presents many magnificent scenic vistas to the traveler." (Author's collection.)

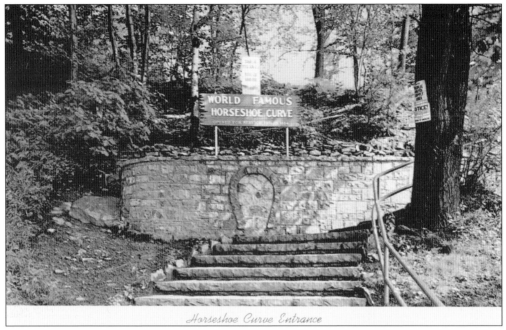

Horseshoe Curve Entrance

A 1950s postcard shows the entrance steps to the old stairway to railroad track level, which were arduous to climb because of varying risers. This signboard still survives into the 21st century as an exhibit in the visitors' center, which opened in April 1992. Many tourists had their photograph taken at this location. The horseshoe and the stone wall shown here still survive also, but the upper steps have been relocated. (Author's collection.)

Bessie Barnhart, later Mrs. Clyde Tritsch of Butler, visits Horseshoe Curve in August 1947 at the stairs leading up the hillside to track level. Many visitors have had their photograph taken here. The sign above the pole frame has welcomed visitors to Horseshoe Curve for many decades and survives at the Horseshoe Curve visitors' center in 2008. (Author's collection.)

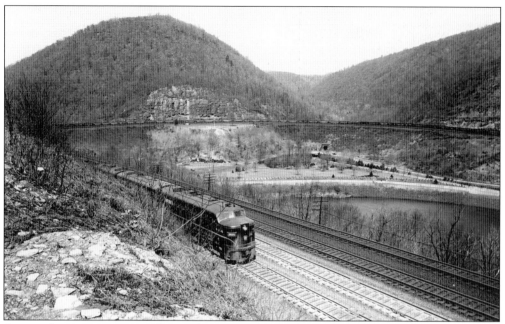

Seen in this expansive view of Horseshoe Curve from the west ridge is a long train of empty coal hopper cars westbound, powered by Alco (American Locomotive Company) FA2 locomotives in an A-B-A arrangement, with lead unit 9614. They are all rated at 1,600 horsepower. Alco FA and PA locomotives were considered by many to be the most aesthetically pleasing external design, although mechanically, the products of Electro-Motive Division (EMD) of General Motors were more dependable. (Author's collection.)

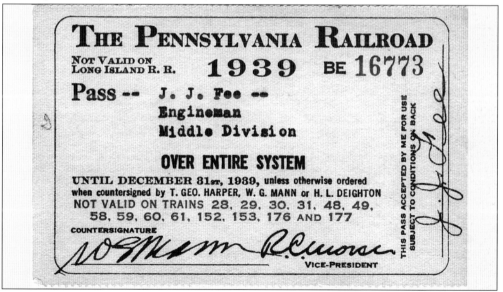

PRR employees were always permitted to travel using a trip pass. Pictured here is a pass issued to J. J. Fee of Altoona, who was an engineman on the Middle Division. However, certain restrictions applied on the use of the pass, most notably a prohibition to board the road's best first-class trains. Fee was a highly respected resident of Altoona's Fifth Ward during his lifetime. (Author's collection.)

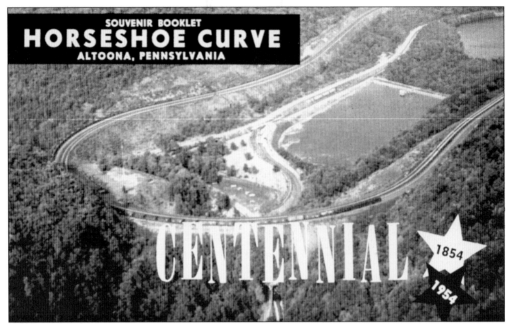

SOUVENIR BOOKLET
HORSESHOE CURVE
ALTOONA, PENNSYLVANIA
CENTENNIAL 1854 1954

The year 1954 marked the centennial year for the Horseshoe Curve as depicted in this cover from a publicity brochure. Horseshoe Curve Park is nestled in the apex area of the curve, and three reservoirs float on the valley floor (two visible in this view). A westbound coal hopper train is shown in this view, returning empty to mines in the counties to the west for another load. (Author's collection.)

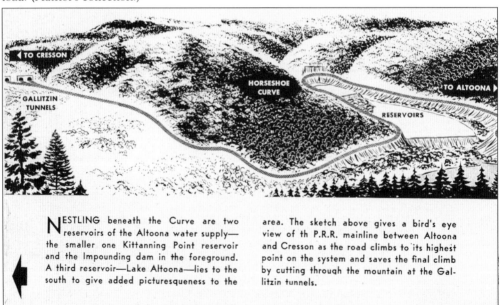

NESTLING beneath the Curve are two reservoirs of the Altoona water supply—the smaller one Kittanning Point reservoir and the Impounding dam in the foreground. A third reservoir—Lake Altoona—lies to the south to give added picturesqueness to the area. The sketch above gives a bird's eye view of th P.R.R. mainline between Altoona and Cresson as the road climbs to its highest point on the system and saves the final climb by cutting through the mountain at the Gallitzin tunnels.

This diagram clearly shows the PRR's ascent over the Allegheny Mountains from Altoona via the Horseshoe Curve. In the approximately 12-mile distance from Altoona to the Gallitzin Tunnels where the line crosses the eastern continental divide, the road climbs at about 91 feet to the mile, thereby climbing almost 1,200 feet in elevation and hauling long trains of commercial products as well as passengers. (Author's collection.)

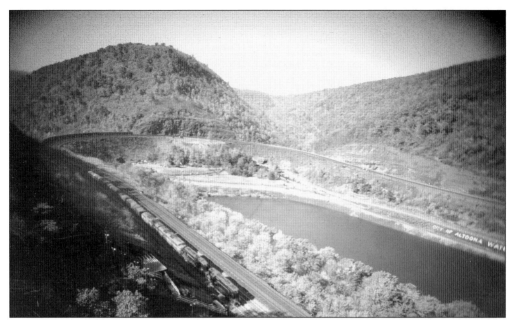

In this October 20, 1954, image, a westbound freight train ascends the Allegheny Ridge. It appears a train powered by F-7 locomotives is being assisted by two helper locomotives ahead, probably GP-7 (general purpose), all manufactured by EMD of General Motors. For this photograph, Don Baker is in position for a scheduled centennial night photograph of Horseshoe Curve after darkness descends. (Courtesy of Don Baker.)

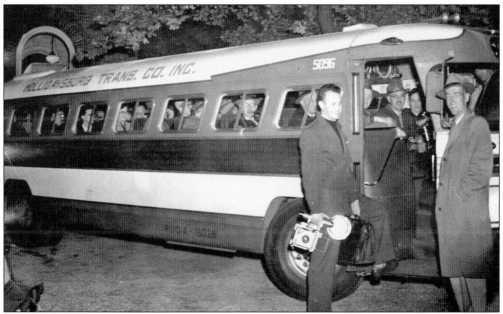

In observance of the 100th anniversary of Horseshoe Curve, a spectacular night photograph was to be taken by Sylvania Electric Products Company and the PRR. Visitors to Horseshoe Curve were by ticket or invitation only. In this image, a Flxible model bus of the Hollidaysburg Transportation Company prepares to depart with local photographers, many from the Altoona Camera Club. The people in this view are not identified. (Courtesy of Ted Beam.)

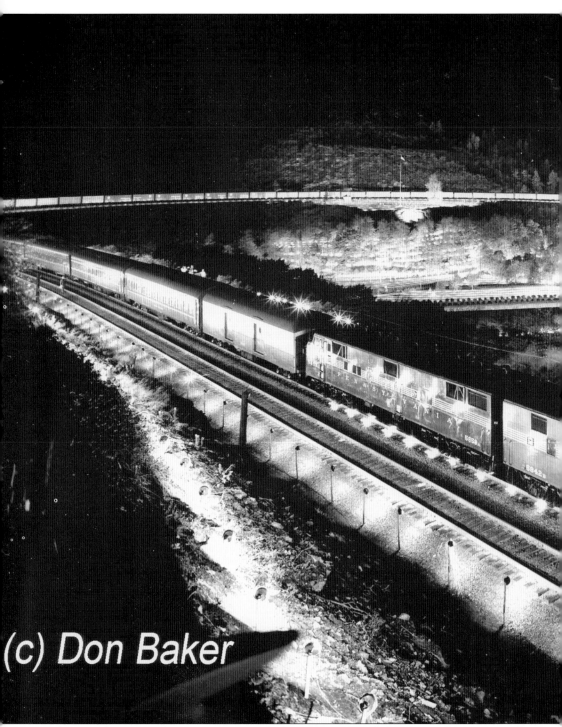

(c) Don Baker

Sylvania Electric Products Company and the PRR arranged for this night photograph of Horseshoe Curve. Sylvania, which had a factory in nearby Altoona, used 6,000 flashbulbs on pie-plate reflectors to capture this image. While not the official photograph, this impressive image was captured by Altoona photojournalist Don Baker. Stopped in the foreground for the

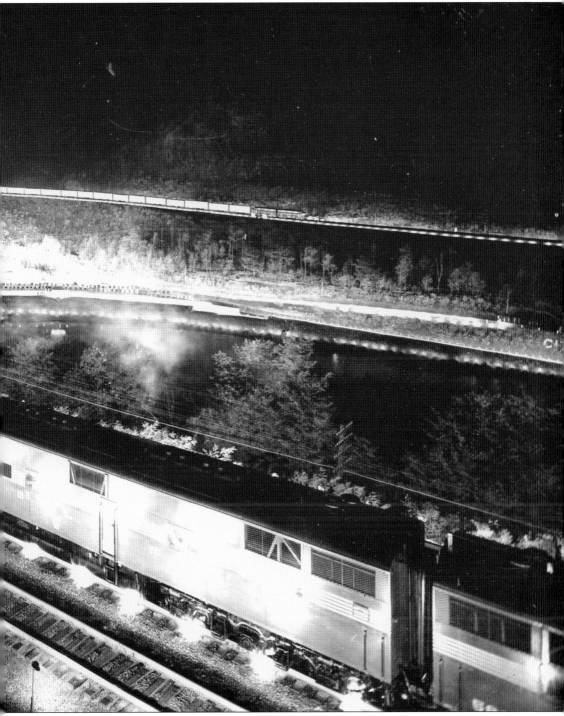

occasion is the westbound *Trailblazer*, with the locomotives brightly illuminated by flares at the side of the track. Aboard the *Trailblazer*, chef V. Redd prepared a special Horseshoe Curve birthday cake for the passengers. (Courtesy of Don Baker.)

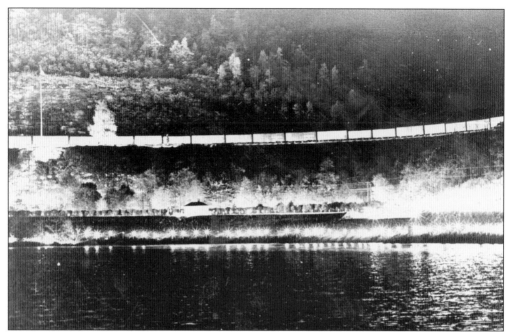

On October 20, 1954, members of the Altoona Camera Club were permitted to participate in a night photograph of Horseshoe Curve by Sylvania Electric Products Company and the PRR, commemorating the curve's 100th anniversary. Photographer Ted Beam captured this image from the breast of the reservoir closest to the visitors' center. (Courtesy of Ted Beam.)

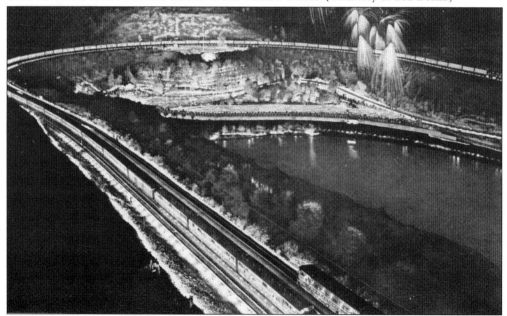

From a postcard image, this view of the official photograph of Horseshoe Curve represents the 100th anniversary of the landmark's opening. Using 6,000 flashbulbs on pie-plate reflectors, Sylvania Electric Products Company and the PRR commemorated this engineering achievement of J. Edgar Thomson, which opened on February 15, 1854. The westbound *Trailblazer* pauses in its journey to participate in the event. (Author's collection.)

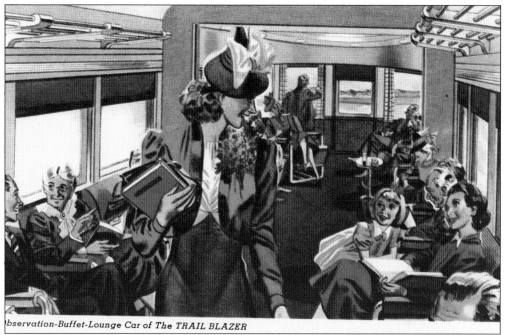

bservation-Buffet-Lounge Car of The TRAIL BLAZER

In this publicity postcard, the PRR illustrates the "Observation-Buffet-Lounge Car of *The Trailblazer* . . . Pennsylvania Railroad's famous deluxe all-coach train between New York and Chicago . . . radio . . . smart Diner . . . Low-priced meals . . . Luxury Coaches . . . attentive service . . . complete air-conditioning . . . high speed travel . . . at low coach fares." The *Trailblazer* was center stage for the 100th anniversary at Horseshoe Curve, October 20, 1954, although the actual date in history was February 15. (Author's collection.)

This vintage postcard view illustrates a well-cindered right-of-way for the PRR four-track main line at Horseshoe Curve. The postcard caption, in part, states, "This area is rugged and replete with natural scenery." (Author's collection.)

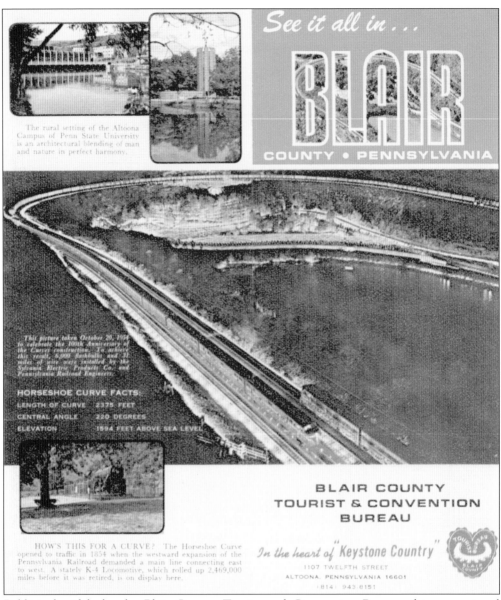

Publicized widely by the Blair County Tourist and Convention Bureau, this promotional brochure captures the tourists' immediate attention with the centennial image of world-famous Horseshoe Curve. Issued after 1957, it still promoted the popularity of the centennial occasion. The intricate flashbulb placement in the vicinity of the concession stand and park and miles of wire strung for the purpose limited visitors to the site for safety reasons. (Author's collection.)

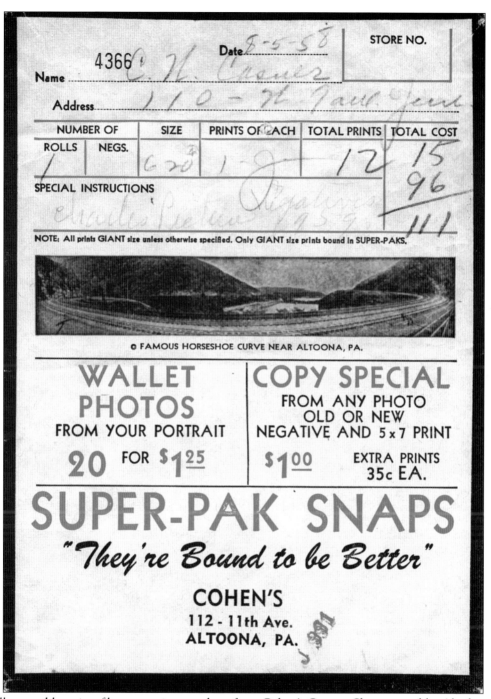

Illustrated here is a film-processing envelope from Cohen's Camera Shop, owned by Abraham Cohen and his son Edgar M., in downtown Altoona. The popularity of the Horseshoe Curve and its association with Altoona, still very much a "railroad town," was incentive for merchants to illustrate Horseshoe Curve on packaging. Many of the Cohens' customers, as well as their competitor Sheldon Burns, nearby, were railroaders who had their Kodak Brownie snapshots of family and friends processed at the stores. (Author's collection.)

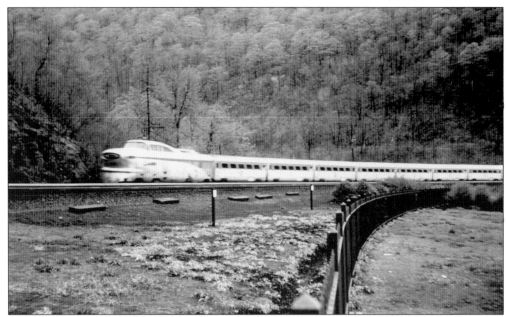

In 1956, dieselization was almost complete. The mechanical efficiencies of these superior locomotives were proven, and the first-generation appearance with streamlined styling appealed to the public. An experiment in this concept was the *Aerotrain* by General Motors, utilized on the PRR for a time to promote travel with a sleek design. However, the *Aerotrain*, seen here westbound on Horseshoe Curve, was known for its rough ride in semipermanently coupled cars. (Author's collection.)

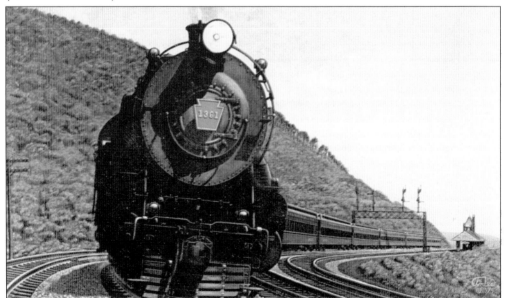

Artist Don Antes Jr. of State College illustrates the passage of a PRR passenger train westbound on Horseshoe Curve depicting K-4s Pacific No. 1361 in this express passing the old Kittanning Point station and signal bridge. K-4s No. 1361 was soon to be preserved and enshrined at Horseshoe Curve as a memorial to the PRR men and women who produced them, and their counterparts, in the Altoona Works and Juniata Locomotive Shops. (Author's collection.)

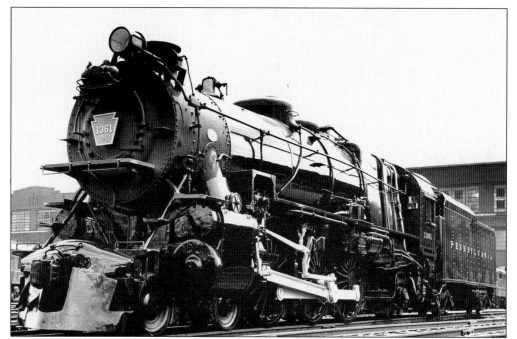

K-4s No. 1361 sits outside the erecting and machine shop, Juniata, in 1957. Retired from service in 1955, its last years in New Jersey, K-4s No. 1361 is about to be placed on permanent display at Horseshoe Curve after a refurbishment. Built in Altoona in May 1918, one of 425 of its class, it logged 2.49 million miles of service, but a decade-long journey still lay ahead for this iron horse. (Author's collection.)

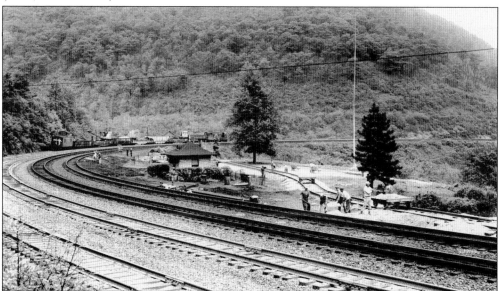

PRR crews, under foreman Oscar Salpino, have constructed a temporary spur track at Horseshoe Curve to prepare a proper resting place for Pacific class K-4s No. 1361 to be placed on permanent display here for the City of Altoona, operator of Horseshoe Curve Park. In the distance, a work train with an N-6 caboose returns to Altoona eastbound on No. 4 track. (Courtesy of Tom Lynam.)

ALTOONA COMMUNITY EXCURSION

TO

HORSESHOE CURVE and RETURN

FOR

DEDICATION OF MEMORIAL K4 LOCOMOTIVE

Presented To CITY of ALTOONA

BY

PENNSYLVANIA RAILROAD

Saturday, June 8, 1957

Train Leaves Altoona 12:30 P. M. (DST)
Going Via Muleshoe Curve

SOUVENIR COUPON — Not Good For Passage.

These adult and child excursion tickets provided passage aboard the excursion special, which left Altoona via the Hollidaysburg and Petersburg branch line to Wye Switches, Duncansville. It then proceeded west on the New Portage Branch via the Muleshoe Curve (see page 12) to Gallitzin Summit through either the Gallitzin or Allegheny tunnel, began a 180-degree loop between UN and AR interlockings, and resumed an eastward journey on the main line to Horseshoe Curve. (Author's collection.)

ALTOONA COMMUNITY EXCURSION

TO

HORSESHOE CURVE and RETURN

FOR

DEDICATION OF MEMORIAL K4 LOCOMOTIVE

Presented To CITY of ALTOONA

BY

PENNSYLVANIA RAILROAD

Saturday, June 8, 1957

Train Leaves Altoona 12:30 P. M. (DST)
Going Via Muleshoe Curve

SOUVENIR COUPON — Not Good For Passage.

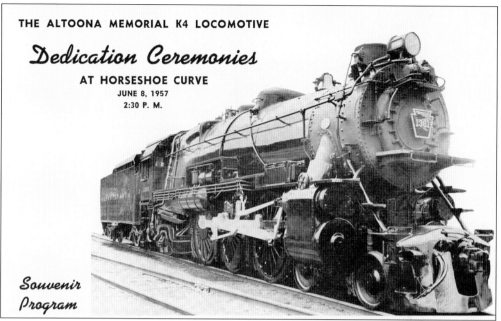

THE ALTOONA MEMORIAL K4 LOCOMOTIVE

Dedication Ceremonies

AT HORSESHOE CURVE
JUNE 8, 1957
2:30 P. M.

Souvenir
Program

Shown is the official program for "the Altoona Memorial K4 Locomotive Dedication Ceremonies at Horseshoe Curve June 8, 1957 [at] 2:30 P.M." It was a jubilant occasion as well as a sad one. The placement of K-4s No. 1361 was certainly a fitting tribute to the many railroad men and women of Altoona but a sad occasion also as the end of steam represented a sharp decline in employment, impacting the city's prosperity. (Author's collection.)

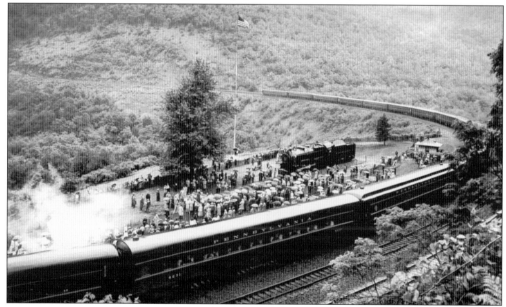

Despite the wet weather on June 8, 1957, the PRR excursion train pauses on No. 1 track to permit riders to gather for the official dedication of K-4s No. 1361 at Horseshoe Curve. Railroad and city officials gathered to commemorate the skills and crafts of Altoona workers who built this locomotive and many others like it. Sadly the PRR would also be history in a mere 11 years, although Horseshoe Curve would remain. (Courtesy of Railroader's Memorial Museum.)

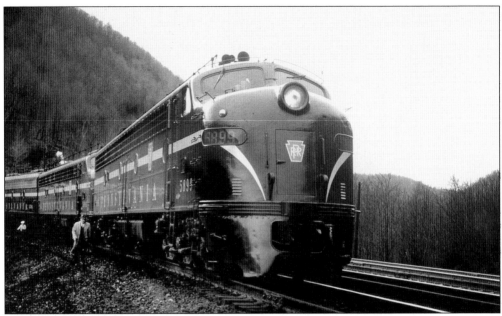

The E-8 locomotive No. 5899 leads sister units at Horseshoe Curve for the excursion special bringing visitors to the dedication of K-4s steam locomotive No. 1361 on June 8, 1957. Five gold stripes have changed to one solid stripe with the impressive keystone herald. As the 1960s would later develop, these polished fleets would become tarnished and the paint would chip as travelers sought the speed of air flights. (Courtesy of Charles Houser Sr.)

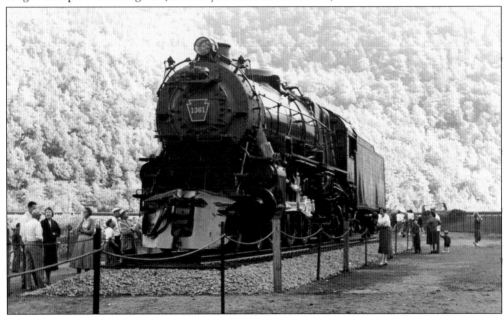

Visitors view the newly placed K-4s steam locomotive in June 1957. Wearing its best face, No. 1361 begins its vigil at Horseshoe Curve, as the railroad passing by it changes dramatically. This iron horse served its owners well from 1918 to 1957, unheard of in the modern age. K-4s No. 1361 rested in this location for the next 28 years before starting a new journey. (Courtesy of Railroader's Memorial Museum.)

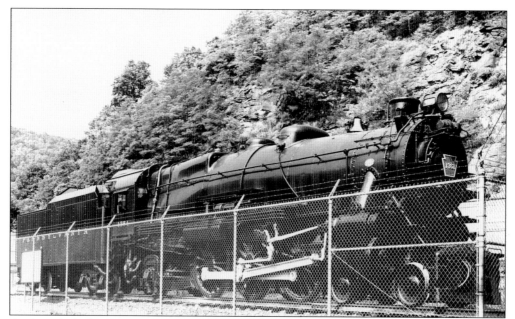

A chain-link fence was placed around K-4s No. 1361 at Horseshoe Curve for safety and vandalism reasons. The fence detracted from the locomotive's majestic stance and made it hard to photograph, but it remained for the next 28 years. The K-4s still reminded everyone of what transpired before and would be only one of 2 such locomotives to survive out of the 425 of that class. (Courtesy of Charles Swartzwelder.)

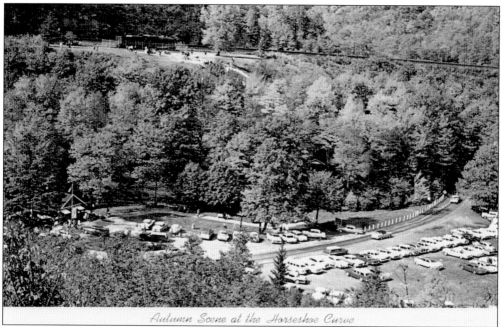

Autumn Scene at the Horseshoe Curve

In this autumn scene at Horseshoe Curve, around 1957, the parking lot and the old concession stand are busy as the leaf peepers come out for the flaming fall foliage and to just watch trains. Autumn at Horseshoe Curve is one of the more spectacular times of the year, when nature's paintbrush renders spectacular vistas for a brief period of time. (Courtesy of Sheldon L. Burns.)

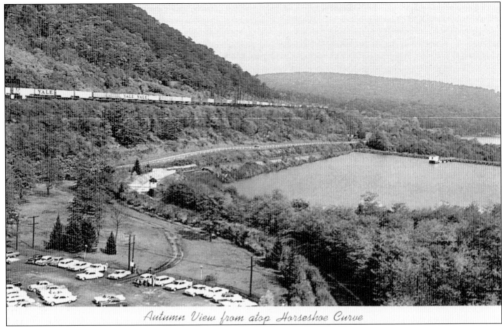

Autumn View from atop Horseshoe Curve

Also an autumn view, a PRR truc-train is on the east side of Horseshoe Curve. The parking lot seems to be full of visitors who came to experience the fall foliage in the late 1950s. In this view, the unencumbered vista of the railroad can be appreciated. Foliage encroachment in future years would make such a scene almost impossible. (Courtesy of Sheldon L. Burns.)

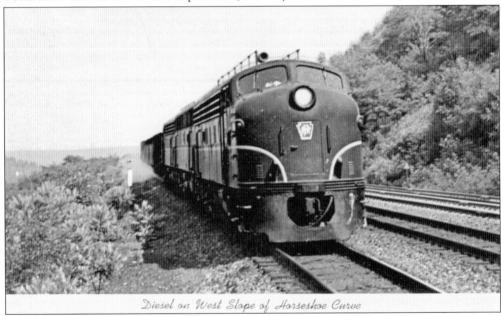

Diesel on West Slope of Horseshoe Curve

In this late-1950s scene, a trio of EMD F-7s eastbound approaches Horseshoe Curve with a coal train nearing milepost 242. Coal has remained a major commodity for shipment through the 19th, 20th, and into the 21st century. This train will enter the Altoona yard at South Tower and will move over the Juniata scales for weighing to eastern destinations. (Courtesy of Sheldon L. Burns.)

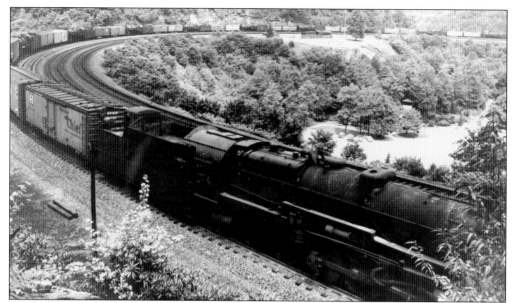

The *Altoona Mirror*, on August 28, 1959, reported on this "Graveyard Train": "A solid train of 15 old Pennsylvania Railroad steam locomotives [Class I-1] . . . moving around the famed Horseshoe Curve near Altoona. The engines, representing 3,211 tons of metal, were en route from Altoona to a Midwestern steel mill to be cut up for scrap. The Pennsy, which once owned as many as 7,630 steam engines, became completely dieselized or electrified more than two years ago." (Author's collection.)

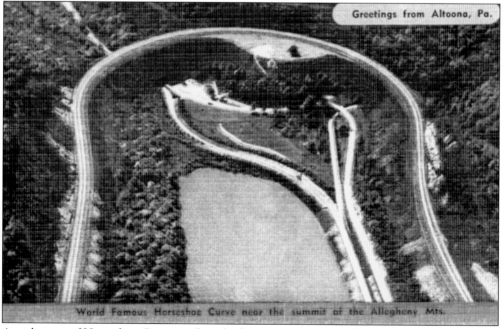

Aerial views of Horseshoe Curve are breathtaking as in this pre-1957 image. Two streams enter the valley: potable Glen White Run on the left and nonpotable (acid mine drainage) on the right, which is characterized by a rusty coloration and is channeled away from the reservoir system. This postcard was distributed by Altoona News Company. (Author's collection.)

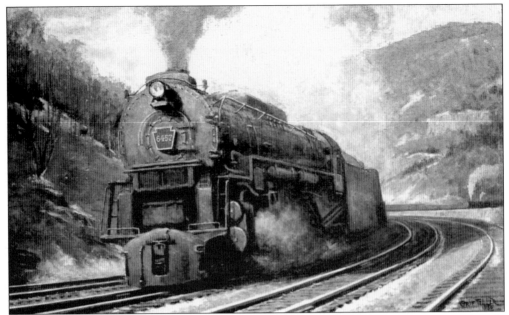

Rediscovered in retirement, post 1974, PRR calendar artist Grif Teller was commissioned to do additional works by the rail-enthusiast community, especially Ken Murry, of Mountville, and Dan Cupper, of Harrisburg, authors of *Crossroads of Commerce: The Pennsylvania Railroad Art of Grif Teller*. This 1986 oil-on-canvas depicts the powerful J-1 Texas type exiting Horseshoe Curve on McGinley's Curve and is displayed at Railroader's Memorial Museum. (Courtesy of Railroader's Memorial Museum.)

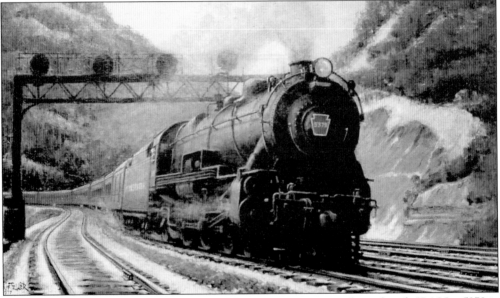

In this image of Teller's oil-on-canvas, a PRR passenger train eastbound with K-4 No. 5379 is exiting Horseshoe Curve. One of many post-retirement commissions, this scene was reproduced on a special edition PRR art calendar for 1980. This image was commissioned by Ken Murry of Mountville and is displayed at Railroader's Memorial Museum. (Courtesy of Railroader's Memorial Museum.)

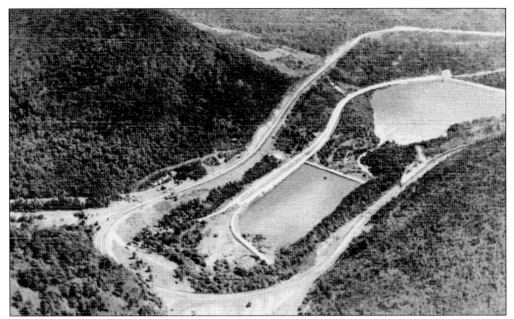

Another aerial view in a postcard image, postmarked June 15, 1938, bears the inscription "Built 1852, the Curve, even today, is considered an outstanding engineering feat. Length of curve, 2375 feet; elevation at east end, 1594 feet; grade 91 feet per mile. Motorists may now reach the curve over State roads, and to see the Pennsy's giant locomotives and long trains climbing up the Allegheny Mountains is well worth the trip." (Author's collection.)

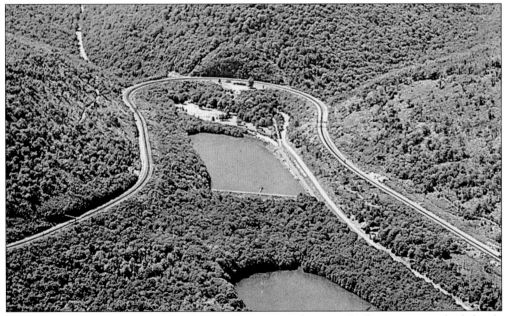

In another expansive aerial view of Horseshoe Curve, the westerly direction is at the left side and east to the right. The main line hugs the hillsides in its steady climb. Although many of the premier passenger trains passed over this terrain during nighttime hours, those that traversed the landscape during daylight were afforded a most spectacular view. (Courtesy of Sheldon L. Burns.)

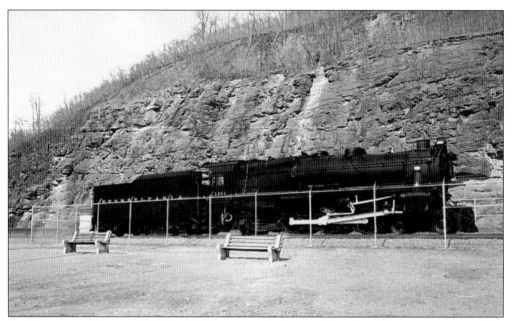

In this postcard image, K-4s No. 1361 rests on display at Horseshoe Curve as time marches on. The drive rods are painted aluminum for cosmetic purposes but were never painted when the locomotive was in service. Horseshoe Curve has remained a popular destination for all its existence and is particularly pleasant on summer evenings accompanied by a sight and sound show along the busy main line. (Courtesy of Sheldon L. Burns.)

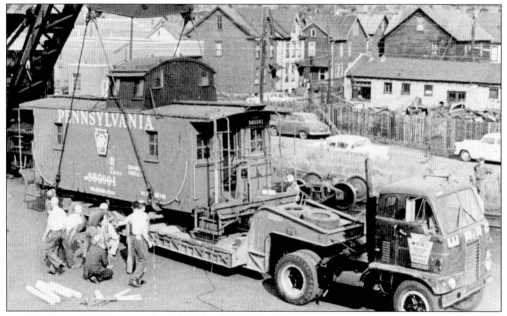

In this view, a PRR steam derrick is loading a wood class N-6B caboose onto a flatbed truck provided by Ward Trucking Company. This caboose was transported to Horseshoe Curve and installed near the concession stand. Loading occurred at Fourth Street, Altoona, near what was formerly the livestock pens where cattle had to be detrained and provided feed and water in an earlier time. (Author's collection.)

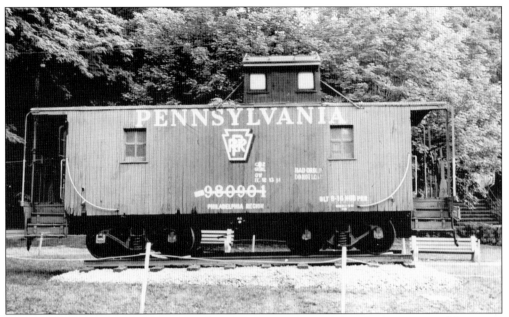

This PRR class N-6B was constructed in August 1916. At the end of its service life, it was placed on display near the concession stand for public view. The white line drawn through the serial number (whitelined) meant withdrawn from service and awaited further disposition. This caboose had friction bearings, which were obsolete, rather than roller bearings, which required little or no maintenance and were safer. (Author's collection.)

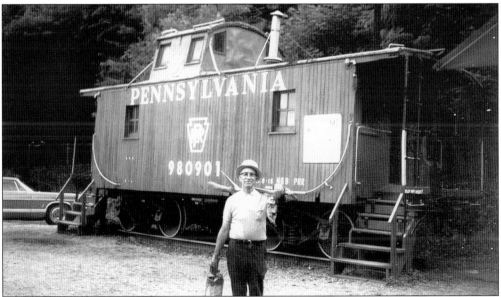

Oscar Salpino is legendary in Horseshoe Curve history. For 50 years he worked on a six-mile section of railroad, including Horseshoe Curve, as laborer, section foreman, and general foreman. In retirement, he became groundskeeper at Horseshoe Curve Park and was highly respected and admired by all. Salpino repainted the N-6B caboose (rear), which was restenciled by Lawrence Edwards of South Amboy, New Jersey, in August 1974. It was burned down by vandals. (Courtesy of Theresa Salpino.)

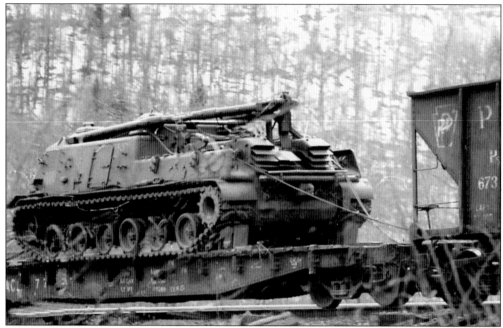

Horseshoe Curve, and the main line east–west route it represents, has always been noted for priority shipments of military and defense materiel. In this view, a U.S. Army tank is being shipped, but entire trains of Department of Defense armaments have been transported on this route. (Courtesy of Barry Kaufman.)

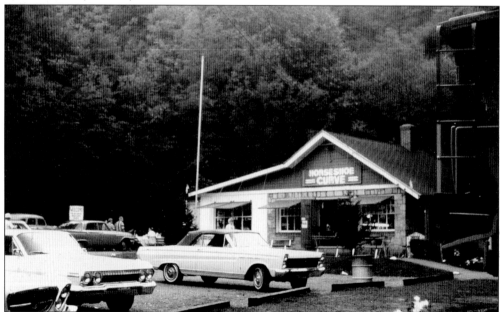

The original Horseshoe Curve visitors' concession was constructed by the Works Progress Administration and was as much of a fixture at Horseshoe Curve as was the landmark for which it was named. Guy Lockard operated the concession for decades, and visitors from all over the world enjoyed Lockard's stories and purchased inexpensive souvenir items, which would become the collectibles of future years. (Author's collection.)

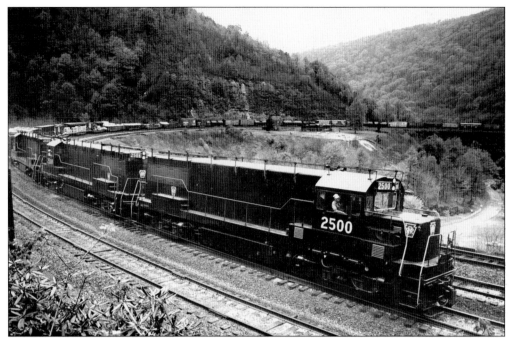

During June 1962, the PRR operated new General Electric U25B diesel-electric locomotives 2500, 2508, and 2502 over Horseshoe Curve. Rated at 2,500 horsepower, they are equipped with train-phone antennae and dual control. Railroaders dubbed them "U-Boats." Ironically, just 20 years earlier, German U-boats landed would-be saboteurs on the shores of Long Island and Florida with plans to sabotage U.S. industry, including Horseshoe Curve. (Author's collection.)

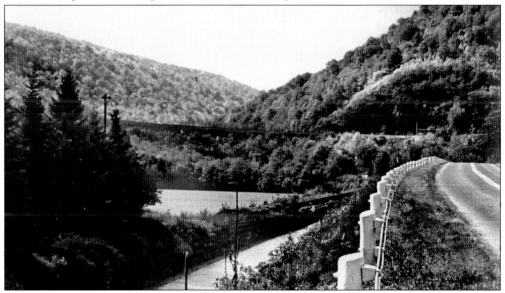

In this 1960s view, Horseshoe Curve is seen from the roadway approach. The channel to the left of the white painted guard posts diverts the rusty waters of Kittanning Run away from the city reservoirs and contrasts strikingly with the blue-green potable waters of the city of Altoona's reservoirs. K-4s No. 1361 is seen in the distance at Horseshoe Curve Park where it was placed on June 8, 1957. (Author's collection.)

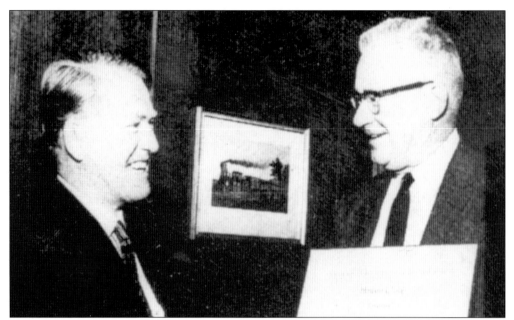

Horseshoe Curve was designated a registered national landmark in 1966. Allen J. Greenough, president of the PRR, accepts a certificate signed by Stewart L. Udall, secretary of the interior, designating the PRR's Horseshoe Curve as a registered national historic landmark. Making the presentation in Philadelphia (May 1967) is Dr. Murray H. Nelligan, special assistant to the regional director of the northeast regional office of the National Park Service. (Courtesy of Altoona Mirror.)

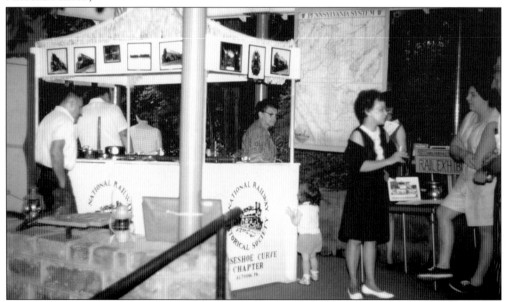

The Horseshoe Curve Chapter, National Railway Historical Society, provided an exhibit of railroad memorabilia on August 3, 1969, at the Horseshoe Curve. At right-center Bernice M. Wahl explains some of the exhibits for the visitors. Horseshoe Curve Chapter, National Railway Historical Society, had a goal of establishing a railroad museum facility for the Greater Altoona area and creating awareness of Altoona's railroad heritage. (Author's collection.)

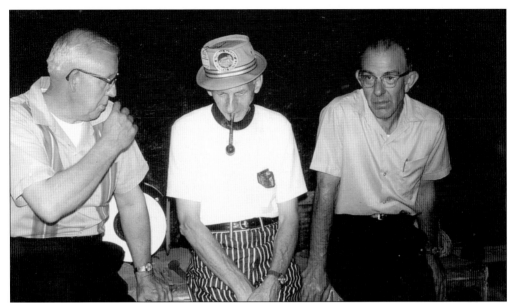

Similar to the preceding view, members of the Horseshoe Curve Chapter, National Railway Historical Society, discuss their railroad experiences at Horseshoe Curve on August 3, 1969, and share their information with visitors. Shown from left to right are Paul Burrows, Joseph F. Wahl, and Paul Westbrook. These gentlemen devoted many hours as advocates for the chapter, including locomotive restoration projects. Westbrook served as the chapter's president for over a decade. (Author's collection.)

The parking lot of Horseshoe Curve in the 1970s is still busy with visitor traffic, most of whom will climb the 100-plus steps to the railroad grade level to enjoy the passing railroad traffic. In this view, a covered-hopper train is seen on the east side of the curve in the background. In another 20 years, the entire property would be razed and a new visitors' center constructed to better interpret the site. (Author's collection.)

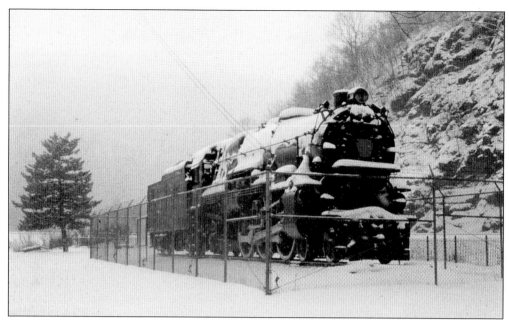

Class K-4s steam locomotive No. 1361 continues as mountain sentinel gracing Horseshoe Curve National Historic Site in this winter scene. Clad in a blanket of fresh snow, Horseshoe Curve is still a magnet for the fewer winter visitors but is always a draw for the many visitors who enjoy the change of seasons. The K-4s, believed never to operate again, reminds everyone to never say never as the future holds surprises for all. (Author's collection.)

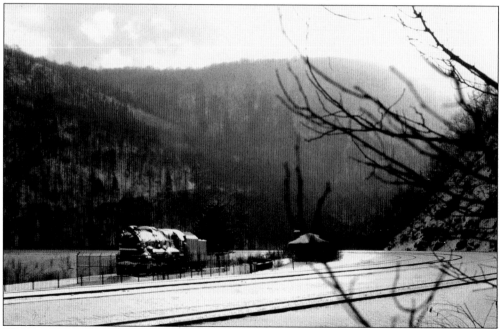

The mountains sleep in winter, dusted with fresh snow, as does the magnificent steam locomotive seemingly awaiting a call to action. In an otherwise bleak day, an afternoon shaft of sunlight bursts from the Glen White hollow to enhance the dreary scene. Bathed in light, the tracks seem to beckon for activity. (Author's collection.)

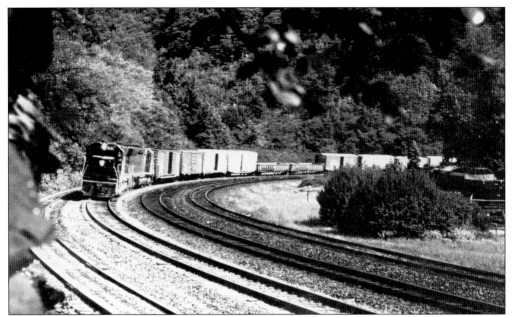

In 1967, the final days of the PRR are numbered as this westbound freight consist reaches the apex of Horseshoe Curve on No. 3 track. Helper locomotives are probably on the rear pushing hard against the caboose. The K-4 locomotive memorial is seen on the right, but vegetation outside the Horseshoe Curve Park fence line is maturing and obscuring part of the view. (Author's collection.)

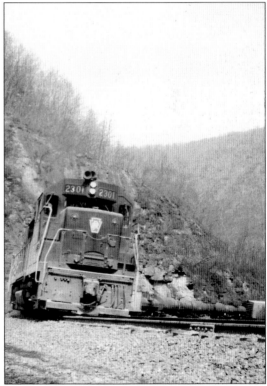

A westbound mixed freight rounds Horseshoe Curve, having just passed milepost 242, powered by GP-35 No. 2301 manufactured by EMD of General Motors in 1964. In this early spring 1967 image, the soon-to-be ill-fated merger with the New York Central Railroad is just months away, February 1, 1968. The resulting bankruptcy will plunge both roads into a financial chasm with no resolution without government intervention. (Author's collection.)

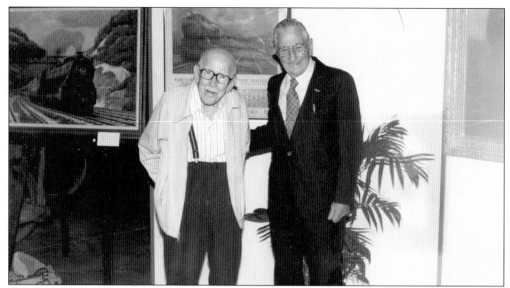

On October 1, 1982, Grif Teller (right), renowned artist for most PRR art calendars, visits the relatively new (September 21, 1980) Railroader's Memorial Museum in Altoona to exhibit many of his original masterpieces. Guy Lockard, retired concession operator at Horseshoe Curve, meets Teller on this occasion. In Altoona, Teller and Lockard were icons of all things PRR and held in the highest regard. (Author's collection.)

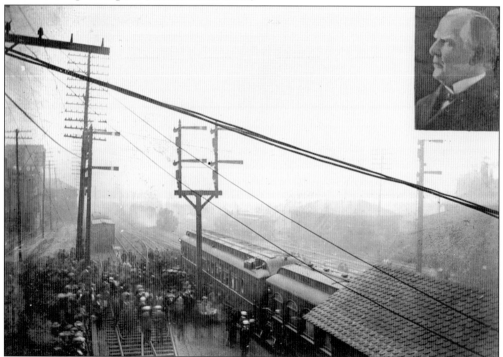

Many presidents have traveled the PRR, sometimes in repose. In this view, Pres. William McKinley's funeral train pauses on its westbound journey at Altoona on September 18, 1901. Soon it will travel over Horseshoe Curve en route to Canton, Ohio. The morning smoke and fog add to this gloomy occasion. (Author's collection.)

Three

PENN CENTRAL RAILROAD

On February 1, 1968, the PRR and the New York Central Railroad, merged to form Penn Central Transportation Company, also known as the Penn Central. Unfortunately, history shows that this was to be an ill-fated business decision, which would ultimately lead to one of the largest industrial mega-merger bankruptcies of the 20th century. And as if bankruptcy in and of itself was not bad enough, this bankruptcy would, in some circles, be considered the Enron of its day because of the creative accounting practices that contributed to the demise. Cash flow for the new railroad was insufficient for operating expenses and needed capital expenditures, and the practice of deferred maintenance resulted in slow orders, poor service, and frequent derailments. A condition of merger approval by the federal government was the inclusion of the New York, New Haven and Hartford Railroad, which was in poor financial condition. In addition, the New York Central's digital computer system did not communicate with the PRR's analog system, resulting in lost shipments and a multitude of headaches the new railroad was not prepared for. On June 21, 1970, a petition for bankruptcy was filed under federal bankruptcy laws sending shockwaves through the railroad industry, the banking industry, and corporate America in general, requiring government intervention. The impact of the bankruptcy was felt everywhere, including Altoona, where banks were found reluctant to cash railroad workers' paychecks. But, although difficult times were here, trains would continue to operate over the world-famous Horseshoe Curve, and a few very special occasions would draw visitors to the site for the opportunity to observe, participate, and record these events.

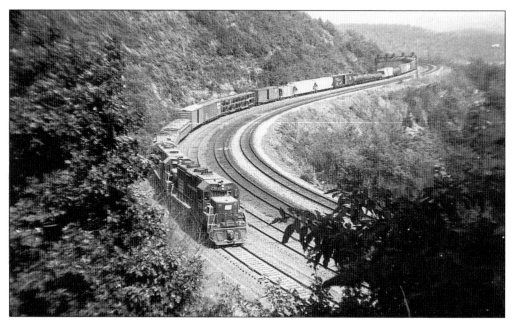

In this postcard, from Audio-Visual Designs, a westbound Penn Central Railroad mixed-freight consist snakes toward the apex of Horseshoe Curve, in an unusual view from cliffside. Gone from the locomotive's nose is the usual keystone logo with the intertwined PRR, replaced by a conjoined PC in white on a black field. Although spartan in some respects, Penn Central did experiment with other colors. (Courtesy of Carl H. Sturner collection.)

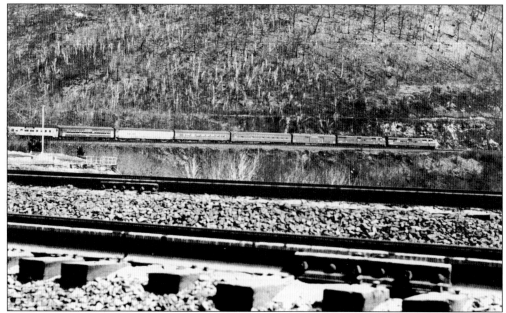

It is March 1969, 13 months into the new Penn Central system, and the eastbound *Pennsylvania Limited* is gliding along the east leg of Horseshoe Curve. Venerable E-7 ex-PRR locomotives lead a Tuscan-red sleeper and coach, stainless ex–New York Central coaches, and a coach in the new Penn Central green with white PC logo. Later locomotives would be painted black with white logos, but free of any artistic lettering and striping. (Author's collection.)

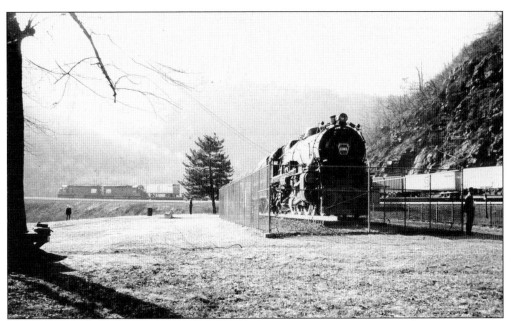

November 1971 finds a westbound Seatrain truc-train over Horseshoe Curve as ex-PRR K-4s No. 1361 remains as a sentinel to this new era in Horseshoe Curve history. While few tourists are out on this chilly day, one can imagine the sights and sounds as the SD-45 diesel-electric locomotives ascend the eastern slope of the Allegheny Mountain range, headed for the summit at Gallitzin to cross the eastern continental divide. (Author's collection.)

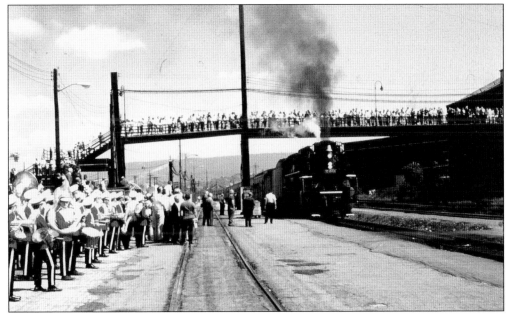

On September 12 and 13, 1970, the High Iron Company operated steam excursion trains from Harrisburg to Altoona, Horseshoe Curve, and Gallitzin tunnels. This was the first steam operation in the Altoona area since 1957. Greeted by local citizens and visitors, including the Altoona Area High School band at the Altoona station, the 18-car train, powered by a Nickel Plate Road Berkshire-class, was headed to Horseshoe Curve. (Author's collection.)

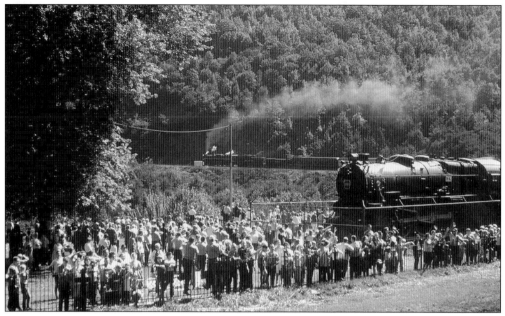

This photograph was taken on September 12, 1970, at Horseshoe Curve. Nickel Plate Road Berkshire-class No. 759 ascends the Allegheny Mountain range west of Altoona, in this view from the High Iron Company observation car *Brothers Two*, passing K-4s No. 1361. Although the K-4 could not have pulled 18 cars up this mountain grade, its decades of service made it an icon of passenger transportation for the former PRR. (Author's collection.)

On September 12, 1970, Nickel Plate Road Berkshire-class No. 759 climbs the west gradient of Horseshoe Curve with 18 cars in a steady climb without assistance. Just around the next curve is MG Tower, and the Gallitzin tunnels are about five miles farther. Although the black coal smoke leaves its imprint on the skyline, it was this industrial might that built American cities and states, providing employment for millions. (Author's collection.)

In this view in the early 1970s, an eastbound Penn Central mixed-freight train, led by SD-40 No. 6052 manufactured by EMD of General Motors, descends easterly into Horseshoe Curve. Some elements of Penn Central's deferred-maintenance policy is evident as weed growth can be seen on the right-of-way, very unusual for this magnificent "broad way" link between eastern and western markets. (Author's collection.)

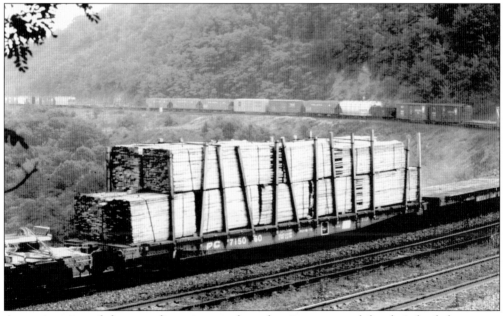

A continuation of the preceding view, eastbound trains are noted for their loaded status as products move to eastern markets, especially lumber products as shown. A slight wisp of brake shoe smoke is evident, an aroma pleasing to some and objectionable to others. To railfans, the aroma of brake shoe smoke and creosote from railroad ties on hot summer days could be pleasing indeed but has since been improved for environmental reasons. (Author's collection.)

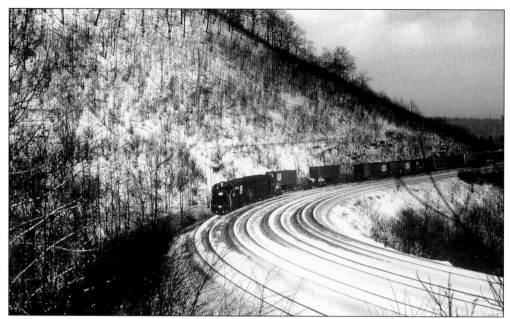

Led by General Electric No. 6513, this class U-25C enters Horseshoe Curve with a westbound truc-train destined for Pittsburgh and western markets. The broad expanse of the four-track main line is well defined in this winter scene, a stark contrast to the opening on February 15, 1854. Locomotive cabs are warm and comfortable, although mechanical issues might require the conductor and brakeman to walk the length of any train. (Author's collection.)

Gleaming paint, striping, and lettering of the streamlined era, conveying luxury, speed, and comfort, are long gone, replaced by somber black, devoid of ornamentation. These heritage units are showing their age in the early 1970s as they pass over Horseshoe Curve. Premium paintwork is not part of the bottom line as passenger losses continue to rise. (Author's collection.)

Winter at Horseshoe Curve is always an attraction for railroad photographers. Snow highlights the landscape to enhance visuals, even on a cloudy day, due to the lack of vegetation. Seasons at Horseshoe Curve, especially spring and autumn, are a tonic to the senses as light and shadow, gloom and sunshine make no two days alike. This westbound consist is led by SD-40 No. 6249, a product of EMD of General Motors. (Author's collection.)

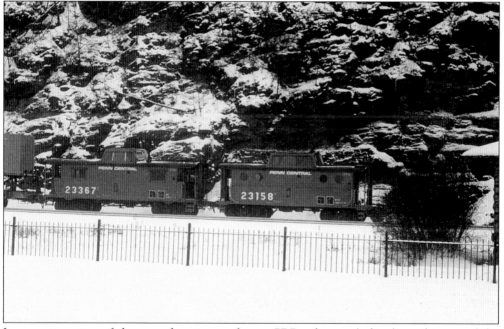

In a continuation of the preceding image, former PRR cabooses (cabins) on the rear of the westbound train are seen. Formerly painted in boxcar red, these units now wear green with white lettering. Pictured from left to right are N-8 class caboose No. 23367 trailed by N5c class caboose No. 23158 at the apex of the world-famous Horseshoe Curve. (Author's collection.)

In this unusual perspective from the west side of Horseshoe Curve is a westbound mixed freight in a view to the trailing cabooses and helper units on the east side. The steel outline of a water tank is visible on the hillside, which served steam locomotives of that era. Stick rail of 39-foot lengths bolted together is still in use as welded rail is still a few years away. (Author's collection.)

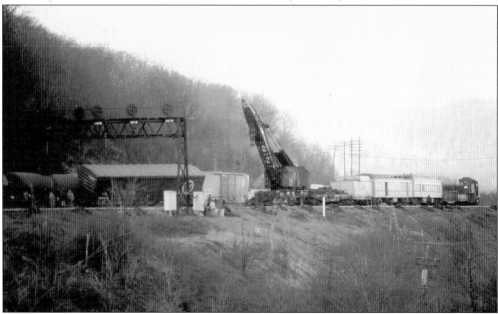

Accidents do happen from time to time. This derailment required the wreck train be ordered from nearby Altoona. Such trains were positioned at strategic points on the railroad and were always ready to roll. Here the derrick is preparing to lift on the east boxcar. Usually steam operated, these derricks, often rated at 250 tons, were converted to diesel operation in later years. (Author's collection.)

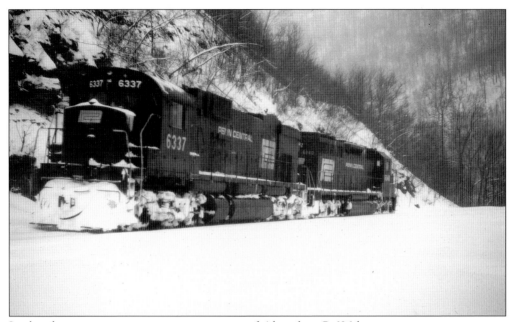

In this dynamic winter scene, a two-unit set of Alco class C-636 locomotives moves east over Horseshoe Curve, returning to Altoona to push another westbound train. All locomotives are equipped with snowplow blades under the coupler to enable continued operation in all weather conditions. The climb from Altoona to Gallitzin is approximately 1,200 feet, and weather conditions change dramatically during this change of elevation. (Author's collection.)

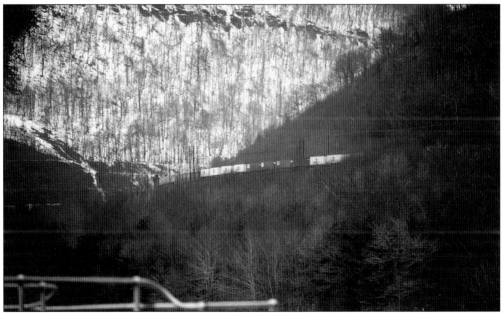

This compressed view, through a telephoto lens, of the final approach to Horseshoe Curve dramatically illustrates the mountain geography that comprises the essence of Horseshoe Curve. In this view from Lake Altoona, one can see an eastbound mixed-freight consist descend the mountain toward Altoona. The light snow clearly outlines the Allegheny Mountain slopes and ledges. (Author's collection.)

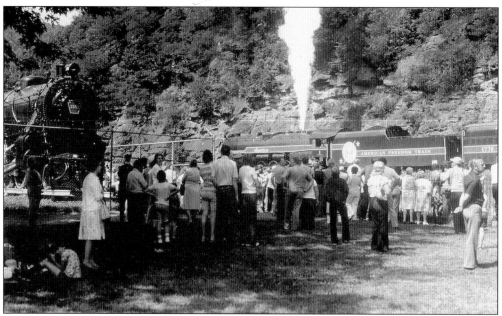

In 1976, America's bicentennial was observed in impressive form via the 26-car *American Freedom Train* traveling the continent with historical exhibits. Steam-powered on the East Coast by ex–Reading Railroad class T-1 No. 2101, an impressive locomotive design with a 4-8-4 wheel arrangement, here it pauses at Horseshoe Curve in July on its westbound journey as the boiler pops off at maximum pressure near ex-PRR K-4s No. 1361. (Author's collection.)

The 26-car *American Freedom Train* stretches eastward out of sight as the locomotive (preceding photograph) pauses on Horseshoe Curve. Filled with treasures representing milestones in U.S. history, these cars were exhibited at major cities that sponsored the train's appearance. Although Altoona was not on that list, Horseshoe Curve certainly was on two occasions—westbound in this scene and later eastbound to another destination. (Author's collection.)

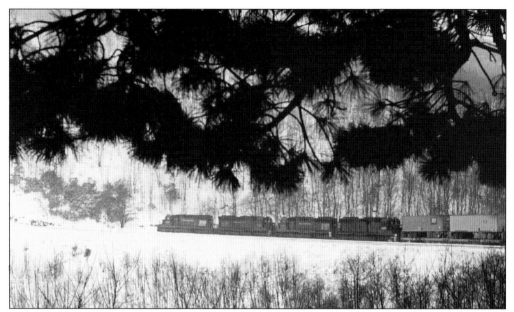

A westbound truc-train ascends the west side of Horseshoe Curve headed toward Pittsburgh, approximately 100 miles distant. Truc-trains (also known as piggybacks) represent preference shipments or fast freight. These intermodal trains, developed during the PRR era, are lighter than standard boxcar shipments, and the flexibility is changing railroad methodology; other innovations would continue into the 21st century as container trains evolved. (Author's collection.)

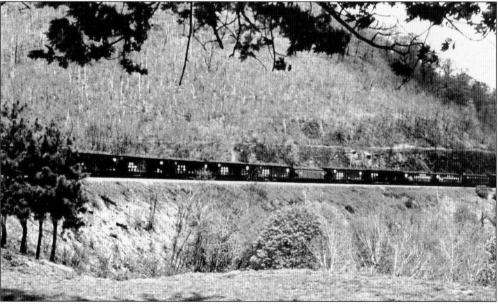

Coal has always been a major commodity shipment over the Horseshoe Curve. Westbound trains are empty, returning to mines in neighboring Cambria, Indiana, and Westmoreland Counties. Once loaded, these trains would resume an eastbound journey, mostly to power plants but also to steel mills that were still operating in the Penn Central era and to ports for export. In this view, an eastbound shipment passes over Horseshoe Curve. (Author's collection.)

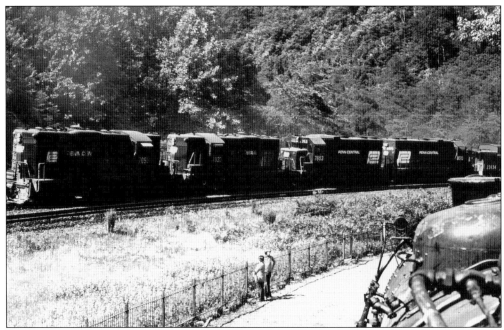

Although Conrail is a reality on paper, Penn Central is still working the mountain over Horseshoe Curve during the transition, as volunteers from the Horseshoe Curve Chapter, National Railway Historical Society, try to maintain K-4s No. 1361 for the city of Altoona in 1976. Ironically, in nine short years, a GP-9 would trade places with the K-4. (Author's collection.)

Members of the Horseshoe Curve Chapter, National Railway Historical Society, contribute to community service with paintwork on K-4s No. 1361, in an attempt to help preserve this steam locomotive memorial at Horseshoe Curve. Displayed at this site for 19 years thus far, time and the elements are enemies to paint, and rust must be controlled. Altoona city provided the paint. Here Joseph F. Wahl repaints the legend board. (Author's collection.)

In this view, Paul W. Westbrook (left), president of the Horseshoe Curve Chapter, National Railway Historical Society, and Wayne T. Reese work to energize marker lights on the tender of K-4s No. 1361 at Horseshoe Curve and perimeter fence lighting. The effort was a continuing battle to stay ahead of vandals who frequented Horseshoe Curve at night. (Author's collection.)

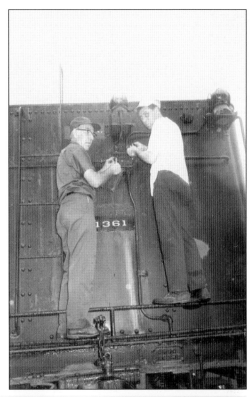

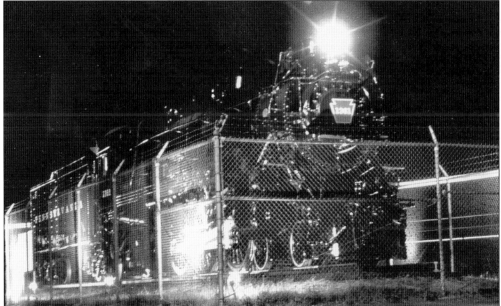

The cosmetic restoration of K-4s No. 1361 has been completed by members of the Horseshoe Curve Chapter, National Railway Historical Society. All marker lights, including the headlight, are brilliant, and the perimeter spotlights illuminate this icon to the industrial might of the PRR, which designed and built this and the sister units of this class, totaling 425, to serve the passenger needs of the system. (Author's collection.)

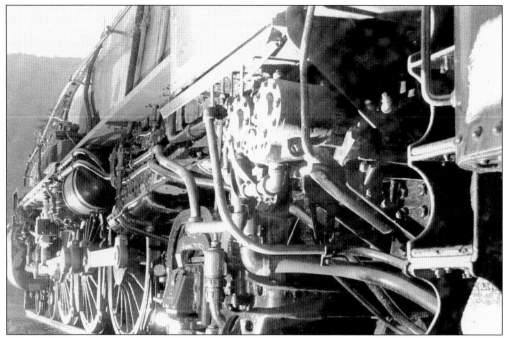

With the cosmetic restoration of Pacific class K-4s No. 1361 complete, this photograph clearly illuminates and details the fireman's side of the locomotive, revealing an intricate assembly of piping, appliances, and running gear. It almost looks ready to depart on an assignment, merely a dream at the time, but little did those who refinished this beast know that it might happen within a decade. (Author's collection.)

Paul Burrows, member of the Horseshoe Curve Chapter, National Railway Historical Society, sits in the engineer's (engineman's) seat following a work session on K-4s No. 1361. Burrows fired on these locomotives in an earlier time, and he is clearly reminiscing about those experiences. Burrows was an ardent steam enthusiast and later helped on the restoration of K-4s No. 1361 to operating condition, in 1986–1987. (Author's collection.)

Four

CONRAIL

Incorporated in Delaware on October 25, 1974, and starting operations on April 1, 1976, Consolidated Rail Corporation (Conrail) was formed by the federal government as an umbrella for bankrupt or near-bankrupt northeastern railroads, especially Penn Central, but also the Reading Company, Lehigh Valley Railroad, Central Railroad of New Jersey (also known as Jersey Central), Lehigh and Hudson River Railroad, Erie Lackawanna Railway, and Ann Arbor Railroad. This included a legion of smaller railroads that were part of these respective systems, too numerous to mention here. Conrail had the monumental task of rebuilding a deteriorated railroad infrastructure in the Northeast as well as implementing many reforms to assure profitability. Starting with losses near $1 million per day, Conrail lobbied for legislative changes resulting in the Staggers Act of 1980, which relaxed the formerly rigid control of railroads by the Interstate Commerce Commission, as well as being relieved of commuter rail operations in the Northeast. With this new legislation, Conrail was able to start showing a profit as early as 1981, much to the credit of chief executive officer L. Stanley Crane (former chief executive officer of the Southern Railway). With continued profitability, and after much debate in Congress, the Conrail Privatization Act of 1986 was signed by Pres. Ronald Reagan on October 21, 1986, enabling Conrail to sell stock to private investors and be removed from government subsidies. With many years of success and profitability established, Conrail became the focus of an acquisition effort in the 1990s, resulting in a division of this remarkable success story between Norfolk Southern Corporation and CSX Corporation, effective June 1, 1999, thus beginning another chapter of history impacting Horseshoe Curve.

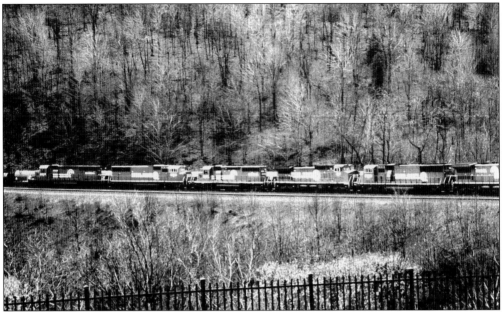

Conrail's early days were a mix of paint schemes, but they have given way to the standard medium-blue field with bold white lettering in this 1980s image. In this view, six westbound locomotives travel Horseshoe Curve, three of which carry the distinctive Q, signifying Conrail quality. Conrail also implemented a Quality Circles management concept, which enabled rank-and-file employees to offer suggestions for better methods and productivity. (Author's collection.)

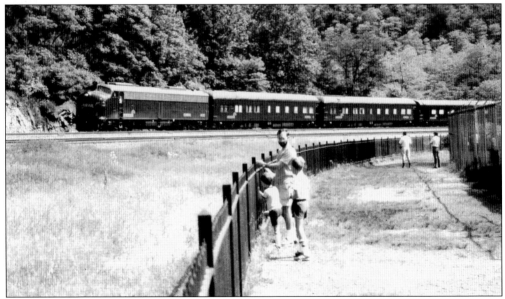

Conrail experimented early with an all-blue business train but opted later for a more traditional Pullman green, a dark olive green shade, seen on this westbound Office Car Special at Horseshoe Curve with modest logo lettering in gold. Class E-8 locomotive No. 4022 leads this train. Business trains were used for system inspection trips or to transport the railroad's best customers to special events as an incentive for their continued business. (Author's collection.)

Here is an additional view of the Office Car Special on the west side of Horseshoe Curve. These cars are from heritage fleets, usually the best of their class, and have evolved from other railroads in their respective histories. These cars are quite luxurious with all amenities, many with open platforms, fine furniture, parlors, dining rooms, and bedroom accommodations. (Author's collection.)

It is September 5, 1985, in Conrail's early history. Railroader's Memorial Museum, only five years old to the month, has agreed to maintain this locomotive for the City of Altoona but needed it moved to its new facility in Altoona. State representative Rick Geist and Conrail chief executive officer L. Stanley Crane agreed to help. K-4s No. 1361 is being prepared for the approximately five-mile journey. These 80-inch drivers are ready to roll. (Author's collection.)

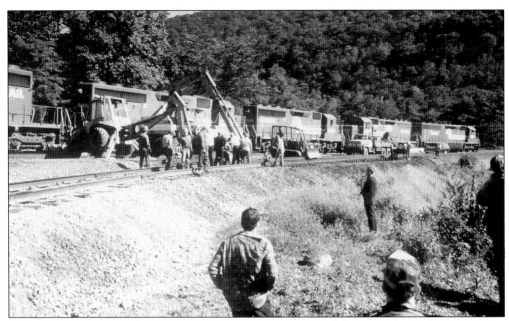

Moving K-4s No. 1361 off Horseshoe Curve required No. 1 track be severed to make connection with the temporary spur constructed for the purpose. Work progresses as eastbound traffic passes. In this attempt, the locomotive will be removed on the east side of Horseshoe Curve, although it was placed there in 1957 from the west end, which allowed for a much more gradual approach. This Conrail project is supervised by Gary Spiegel. (Author's collection.)

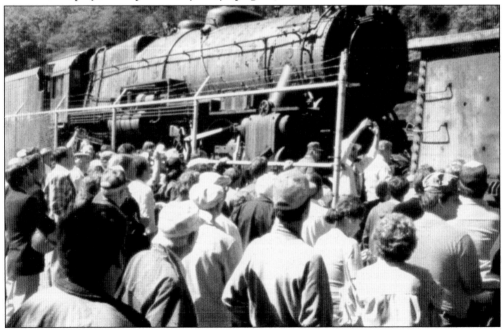

There is no shortage of track supervisors as local residents and railfans turned out to witness the removal of K-4s No. 1361 from Horseshoe Curve on September 5, 1985. In this view, Gary Spiegel (raised arms), Conrail's project superintendent, is signaling the crew coupling a gondola idler car to K-4s No. 1361. (Author's collection.)

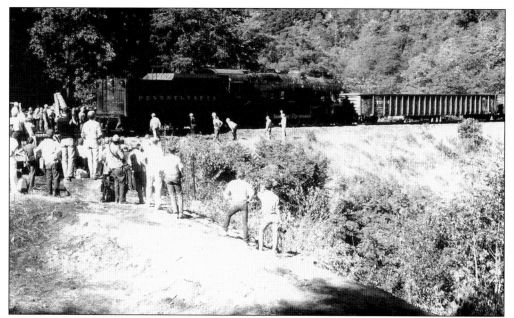

There were many anxious moments as K-4s No. 1361 inched from its berth toward the main line after 28 years. This easterly spur was sharp, and the massive 80-inch drive wheels (six) had a tendency to climb the side of the rail. There were fears, for a time, of a derailment over the embankment. This was a long, hard day for Conrail crews on Horseshoe Curve, but it had a successful conclusion. (Author's collection.)

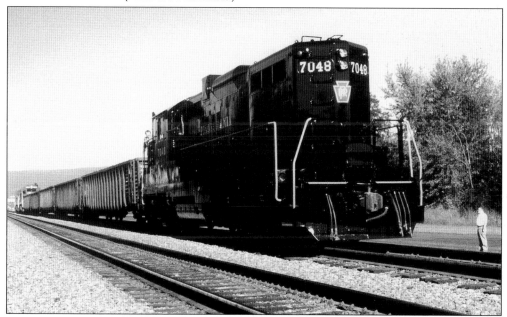

Altoona residents wanted a replacement locomotive for Horseshoe Curve, so arrangements were made for a first-generation diesel locomotive, class GP-9 No. 7048, to be placed at Horseshoe Curve. Repainted in PRR livery by Conrail's Juniata Locomotive Shops, GP-9 No. 7048 is waiting near the Slope interlocking, Altoona. After K-4s No. 1361 passed this location, Conrail units pushed GP-9 No. 7048 west to Horseshoe Curve, where it remains in 2008. (Author's collection.)

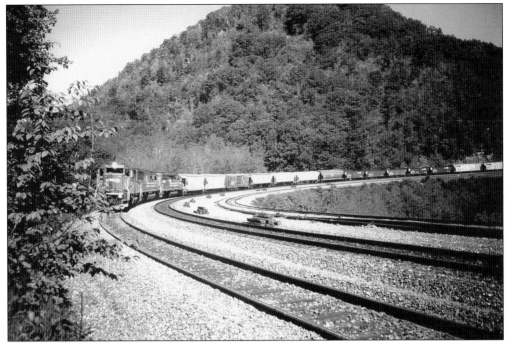

It is a sunny July day as this westbound mixed-freight train rounds Horseshoe Curve. Led by engine No. 6856, an SD-60 EMD product, this train climbs the Allegheny Mountain range with ease with its sister units, and possibly a pair of SD-40-2s on the rear. (Courtesy of Larry G. McKee.)

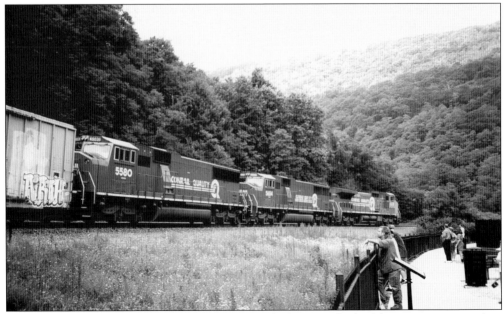

An eastbound train descends the mountain toward Altoona. The lead locomotive is a product of General Electric in Erie and is trailed by a pair of SD-60I units from EMD. Summer grasses outside the fence line might need a trim, but visitors are focused only on the passing scene, an endless parade but an endless fascination for over 140 years. The Conrail Q for quality is a source of pride. (Author's collection.)

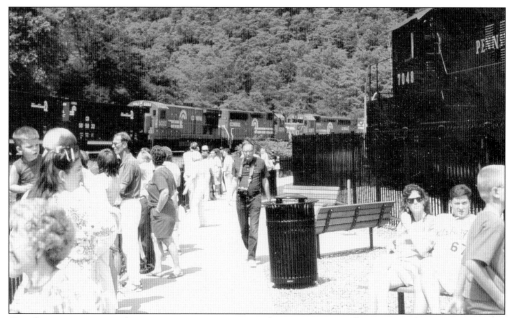

On this nice summer day, many visitors to Horseshoe Curve are all enjoying the passing trains, which provide a symphony of sight and sound. On this occasion, a tour bus has most likely arrived, and the passengers were not disappointed. Prior to 1991, tour buses were unable to access the site due to a 90-degree curve at a bridge and a low clearance culvert under the railroad. (Author's collection.)

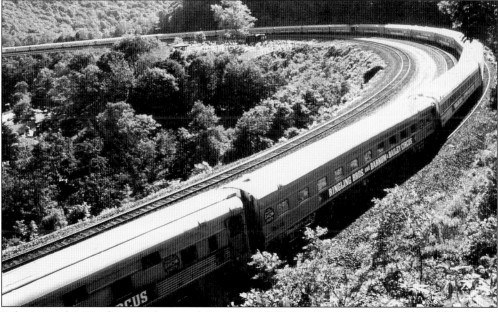

Whenever the Ringling Brothers and Barnum and Bailey Circus train passes over Horseshoe Curve, during daylight hours and known in advance, local residents turn out just to see this famous train pass by, even though animals may be serviced in nearby Altoona with water and feed. This special train holds a special attraction for young and old alike. And if one looks close, an elephant's trunk poking through an open window might be seen. (Author's collection.)

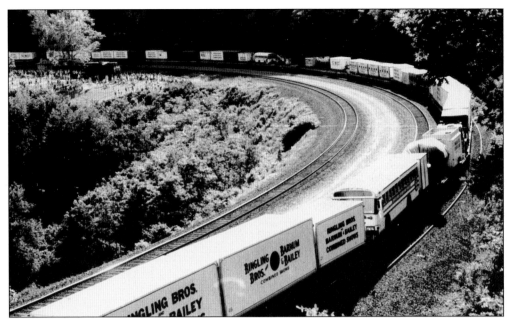

The rear of the Ringling Brothers and Barnum and Bailey Circus train is rounding Horseshoe Curve. The smooth-side passenger cars are forward, and the colorful utility trailers and wagons are on the rear. Circus trains are an eclectic mix of railcars. In this view, it can also be seen that in the Conrail era No. 2 track has been removed from Horseshoe Curve as being unnecessary with new signal and communications systems. (Author's collection.)

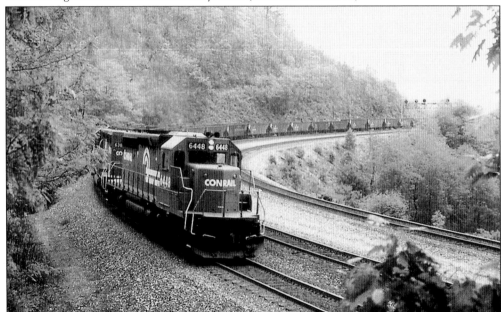

In this well-composed view of Horseshoe Curve, SD-40-2 locomotives led by No. 6448 pull a westbound hopper train for a refill at mines in counties to the west, possibly near South Fork. In the distance, the signal bridge is seen still displaying the PRR-style position light signals. The SD-40-2 locomotives, long out of production, are preferred by engine crews and are maintained in nearby Juniata Locomotive Shops. (Courtesy of Dick Bregler.)

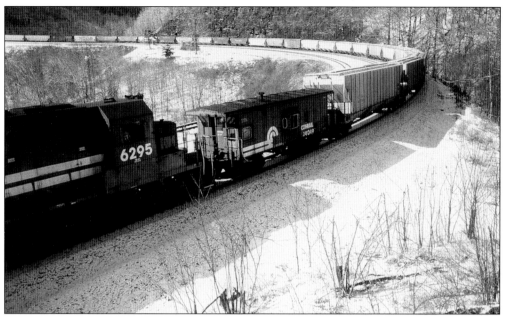

Winter has dusted Horseshoe Curve with a blanket of white in this March 1988 photograph. SD-40-2 helpers push westward against the bay-window caboose of a covered-hopper train, which may have transported grain to eastern markets previously. Sadly the caboose was soon to be relegated to history, replaced by a tiny end-of-train device, which would monitor brake pipe pressure and other functions. (Author's collection.)

In this early-1980s view, new automobiles are traversing Horseshoe Curve in what appears to be a westerly direction, although automobiles are usually eastbound consists. New automobiles are always vulnerable to vandalism. In later years, car carriers would become fully enclosed. In this view, GP-9 No. 7048 is but a speck near the tree at the apex of Horseshoe Curve. (Author's collection.)

An eastbound Conrail train descends the Allegheny Mountains headed for Altoona. Photographed from the western side of Horseshoe Curve in October 1985, the four-unit set of locomotives reach into the eastern side of the curve and Altoona five miles beyond. In the foreground, a Conrail-logo boxcar is followed by a company flatcar laden with wheels, probably for Hollidaysburg Car Shop nearby. (Author's collection.)

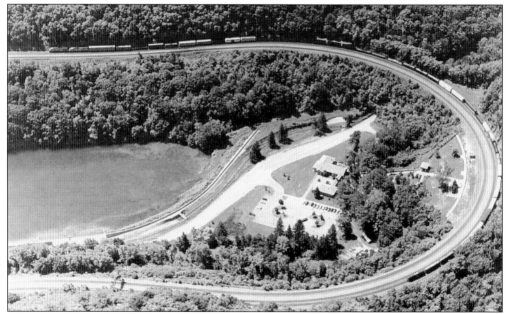

"Nestled deep in the Allegheny Mountains, the world famous Horseshoe Curve west of Altoona, PA, serves 50-60 trains per day. Men using picks, shovels, and mules built this engineering marvel which opened westward railroad expansion in 1854. This national historic landmark includes a visitors' center, funicular, gift shop and seasonal food concession," boasts this c. 1996 postcard view with Thomas Pollard photography. (Author's collection.)

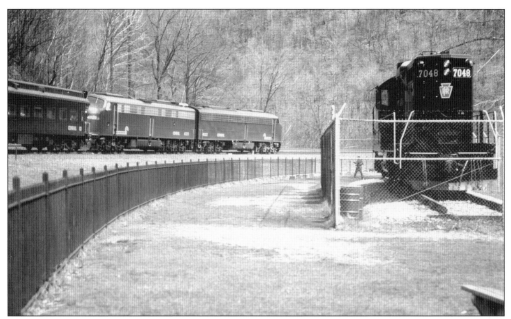

The Conrail office car train glides around Horseshoe Curve eastbound in this March scene, led by E-8 passenger locomotives No. 4022 and No. 4020. GP-9 No. 7048 is the stoic sentinel as one railfan observes the passage of the Conrail livery. Office car No. 10 trails behind unit No. 4022 and, coincidentally, accompanied K-4s No. 1361 on its inaugural run under steam on April 12, 1987, after this historic steam locomotive ended duty on Horseshoe Curve in September 1985. (Author's collection.)

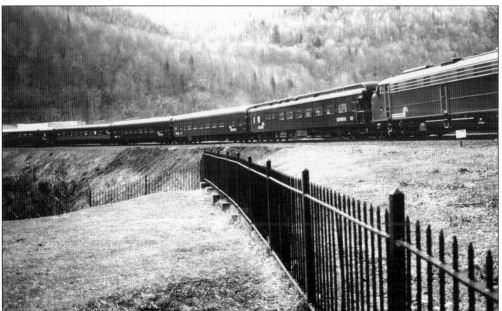

Here is another view of the Conrail office car train rounding Horseshoe Curve in an easterly direction bound for Altoona. Painted in conservative Pullman green, these mansions on wheels glide by a westbound truc-train. The passing landscape still is somewhat stark from the winter season, but the tourists and railfans will reappear as weather improves. (Author's collection.)

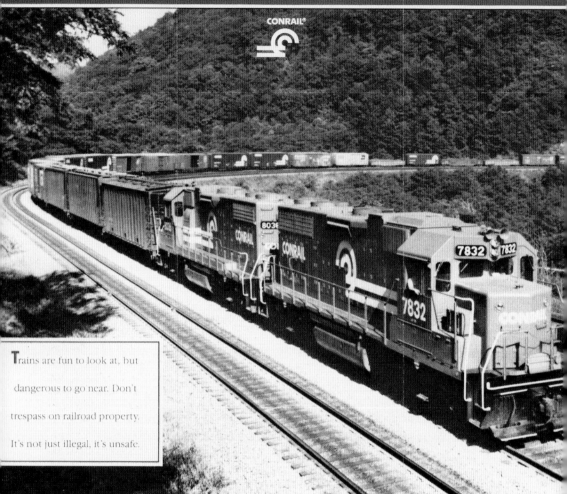

CONRAIL®

Trains are fun to look at, but dangerous to go near. Don't trespass on railroad property. It's not just illegal, it's unsafe.

During Conrail's tenure of Horseshoe Curve, the company published a guide titled *Trains on the Curve*, which was well received by visitors and railfans alike. The guide provided a timetable to traffic on Horseshoe Curve, including freight trains, otherwise only found in employee timetables that were not available to the public. This brochure provides an impressive view of Horseshoe Curve, and the reverse side provides the time schedules, which was an impressive public relations effort. (Author's collection.)

Five

NORFOLK SOUTHERN RAILROAD

The remarkable success of Conrail, formed from several bankrupt railroads, subsidized by the federal government until profitability, with repayment of that debt to the government, resulted in a 23-year history of innovative railroading, essentially rebuilding an entire system. This achievement made Conrail desirable to its competitors, particularly CSX Corporation and Norfolk Southern Corporation. Ultimately, a compromise resulted in a split of Conrail between the two entities, with Norfolk Southern acquiring much of the former PRR territory, representing 58 percent of Conrail's assets amounting to approximately 6,000 route miles, including the Pittsburgh line and Horseshoe Curve effective June 1, 1999. Thus, Norfolk Southern Corporation became the fourth owner of the original PRR route and Horseshoe Curve. Interestingly, the division of Conrail's assets utilized the former reporting marks PRR and NYC, the latter designation going to CSX and the former to Norfolk Southern. Through these four corporate changes, nonetheless, Horseshoe Curve remains a vital east–west rail link with an approximate 70 trains per day using this route. Continual improvements to rail, roadbed, and signaling assures the smooth operation of this route through all weather conditions as locomotive-manufacturing innovations keep pace with emerging technologies.

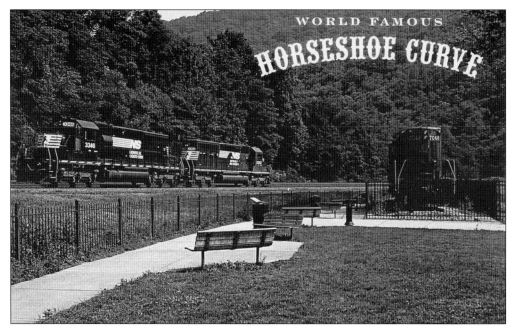

"A pair of Norfolk Southern SD40-2 helpers are drifting downgrade around Horseshoe Curve on August 12, 2005. They are heading to Altoona to push another westbound freight over the Allegheny Mountains. PRR GP-9 # 7048 is on display in the park at the Curve," notes this postcard via Railroader's Memorial Museum. (Author's collection.)

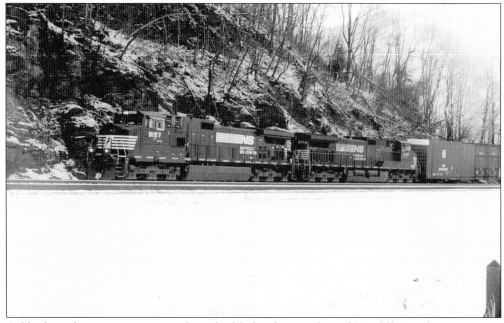

A blanket of snow contrasts nicely to highlight this westbound Norfolk Southern train on Horseshoe Curve led by GE D9-40CW models numbered 9157 and 9719, respectively. These locomotives, rated at 4,000 horsepower each, easily lead this train up the Allegheny Mountain range toward the eastern continental divide toward Pittsburgh and other destinations. (Author's collection.)

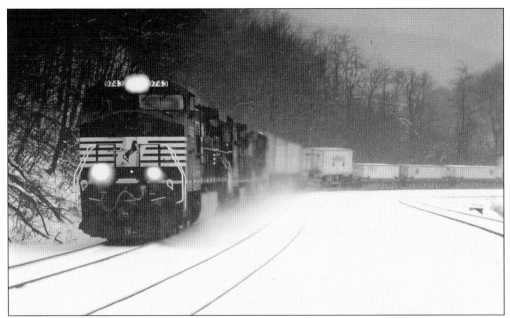

In this February 2003 image, a westbound container train emerges from the swirling snow after having passed milepost 242 on Horseshoe Curve. Led by General Electric class D9-40CW on the point, these 4,000-horsepower engines handle this preference freight shipment with ease. The wide area is the long-since-removed former No. 2 track. (Photograph by Wes Cheney, courtesy of Norfolk Southern Corporation.)

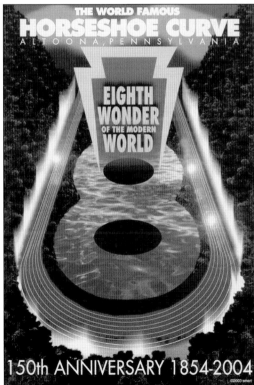

February 15, 2004, was the 150th anniversary of the opening of Horseshoe Curve, but it would be observed on July 4, 2004, at the height of the tourist season. This stylized postcard image of Horseshoe Curve, naming it the "Eighth Wonder of the Modern World" promoted the significance of this event with a light show experience sponsored jointly by Osram-Sylvania and Norfolk Southern to rival the 1954 100th anniversary photograph of Horseshoe Curve. (Courtesy of Railroader's Memorial Museum.)

Keystone Restoration and Preservation organization, of Altoona, replaced milepost 242 to commemorate the 150th anniversary of Horseshoe Curve. This new milepost marker, following the original PRR design specifications, was fabricated by Norfolk Southern employees in the Juniata shops. Installing the milepost marker on December 13, 2003, are, from left to right, Francis X. Givler, David W. Seidel, Pat McKinney (Norfolk Southern maintenance of way), and Patrick McKinney. (Author's collection.)

A trio of Norfolk Southern diesel-electric locomotives leads a container train westbound on the east leg of Horseshoe Curve in this winter scene that nicely highlights the passing landscape on February 15, 2004, the actual date of the 150th anniversary of Horseshoe Curve. An extremely cold day, only a handful of observers were on hand for the occasion as Horseshoe Curve Park was closed for the season. (Author's collection.)

On February 15, 2004, the actual 150th anniversary of world-famous Horseshoe Curve, the few observers who gathered to celebrate this historic occasion are seen here. They are, from left to right, the following: M. Richard Charlesworth, director Horseshoe Curve Chapter, National Railway Historical Society; Dan Cupper, Horseshoe Curve historian and author; Scott Cessna, executive director Railroader's Memorial Museum; and Jody Kinsel. Also stopping by were Peter Barton (former executive director, Railroader's Memorial Museum) and his family (not in photograph). (Author's collection.)

HORSESHOE CURVE
HAS BEEN PLACED ON THE
NATIONAL REGISTER OF HISTORIC RAILROAD LANDMARKS
1854 - 2004
THE FIRST RAILROAD TO CROSS THE ALLEGHENY MOUNTAINS BETWEEN HARRISBURG AND PITTSBURGH, WITH A MAXIMUM GRADE OF 1.87%, WAS ENGINEERED BY J. EDGAR THOMSON 150 YEARS AGO. THE PENNSYLVANIA RAILROAD OPENED THE LINE ON FEBRUARY 15, 1854.

On Saturday, April 3, 2004, the directors of the National Railway Historical Society met in Altoona, hosted by the Horseshoe Curve Chapter. On this occasion, this bronze tablet was presented to Railroader's Memorial Museum, operator of Horseshoe Curve National Historic Site, recognizing the engineering achievement of J. Edgar Thomson and the PRR in building Horseshoe Curve. It is affixed to the exterior wall of the Horseshoe Curve visitors' center. (Author's collection.)

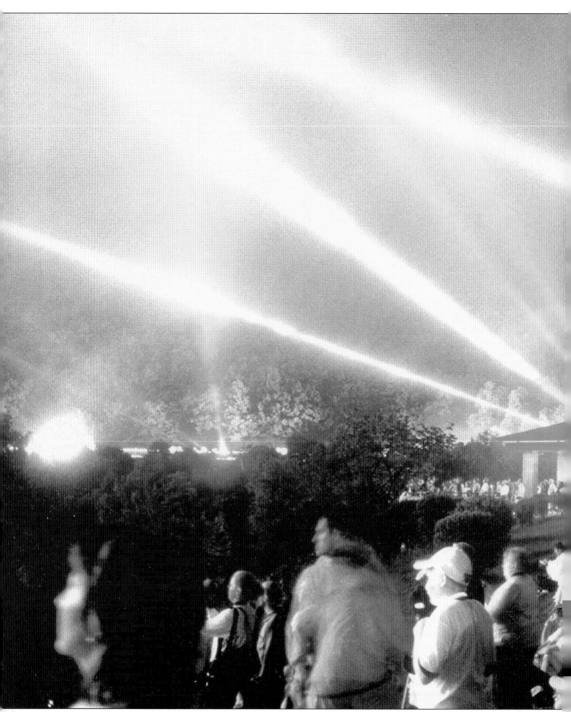

On July 4, 2004, Norfolk Southern and Osram-Sylvania commemorated the 150th anniversary of Horseshoe Curve with a light show on the magnitude of the 1954 flashbulb photograph of the 100th anniversary by the PRR and Sylvania Electric Products Company. Although heavy rains preceded, new container well-cars outfitted with powerful Osram-Sylvania spotlights installed by Bettwy Electric Company of Altoona illuminated Horseshoe Curve and the mountainside

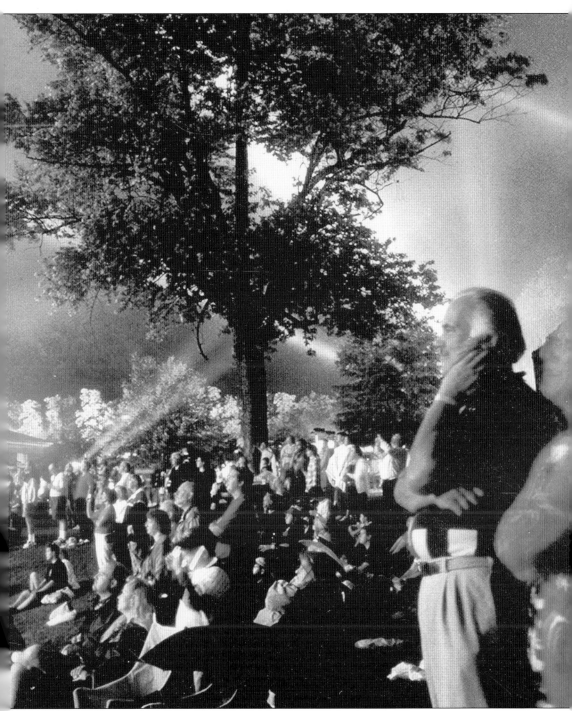

in spectacular fashion as a fireworks show commenced over the Impounding Dam reservoir, entrancing those who braved the elements. The patrons included many VIP guests who arrived on the Norfolk Southern office car train earlier. At the extreme right is John Fischer, of Altoona, an employee of Norfolk Southern's office car train shop in Altoona, now retired. (Author's collection.)

Norfolk Southern participated in the 150th anniversary of Horseshoe Curve with Osram-Sylvania Corporation, which included use of the office car train, time, material, labor, public relations, and security. This also included painting this commemorative hi-cube boxcar, which was later presented to Railroader's Memorial Museum. Here the commemorative boxcar is seen on the newly constructed turntable at the museum. (Author's collection.)

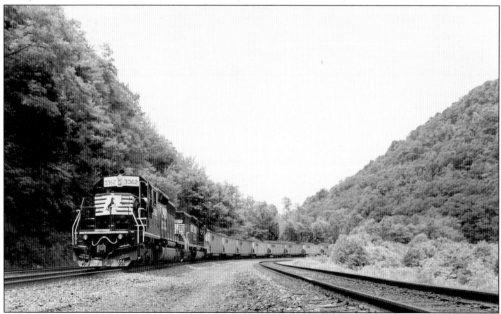

On July 3, 2004, SD40-2 east slope helpers assist a loaded coal train descending eastbound into Horseshoe Curve just around this curve to the right. Coal trains, often 100 or more cars with heavy tonnage, require assistance braking toward the valley floor in Altoona, and the SD40-2, in helper service, is highly regarded by train crews that use them. (Photograph by Leon Guanzon, courtesy of Norfolk Southern Corporation.)

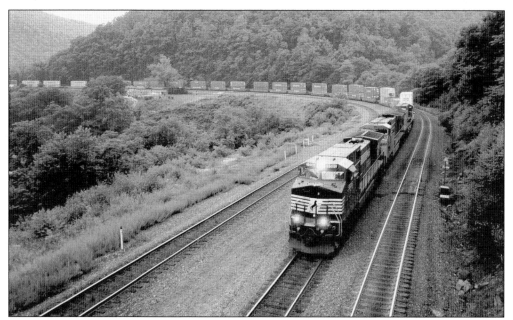

Photographer Leon Guanzon captured this image of an eastbound container train from the signal bridge on the east side of Horseshoe Curve on July 4, 2004, prior to the evening's activities for the 150th anniversary. Four powerful locomotives bring this train toward Altoona led by GE product No. 9506, a D9-40CW. The second locomotive is pool power from CSX Corporation. (Courtesy of Norfolk Southern Corporation.)

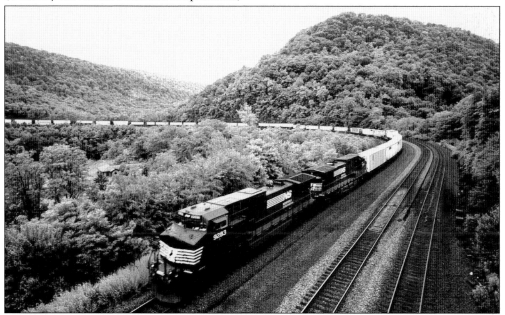

Similar to the preceding image, a Norfolk Southern truc-train heads east around Horseshoe Curve on No. 1 track, also photographed from the signal bridge on the east side of Horseshoe Curve. In this July 4, 2004, image, maturing vegetation encroaches on this spectacular vista, which the photographer's elevation somewhat overcomes. (Photograph by Leon Guanzon, courtesy of Norfolk Southern Corporation.)

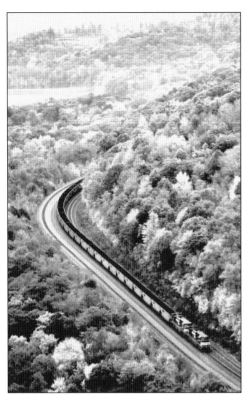

In this aerial view, a loaded Norfolk Southern coal train is on the final approach to Horseshoe Curve, having just passed MG Tower (out of sight). In this view, the autumn foliage is beginning to manifest itself around Norfolk Southern's well-maintained right-of-way. (Photograph by Wes Cheney, courtesy of Norfolk Southern Corporation.)

This is another impressive aerial view of a Norfolk Southern mixed-freight train about to pass milepost marker 242 at Horseshoe Curve. The second and third locomotives are pool power from other roads, but an NS locomotive is on the point as it must be equipped with cab signals. (Photograph by Wes Cheney, courtesy of Norfolk Southern Corporation.)

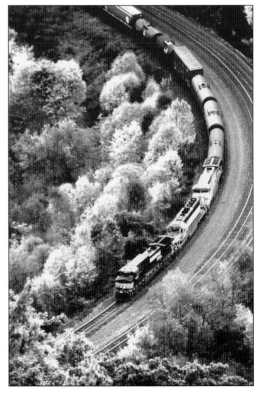

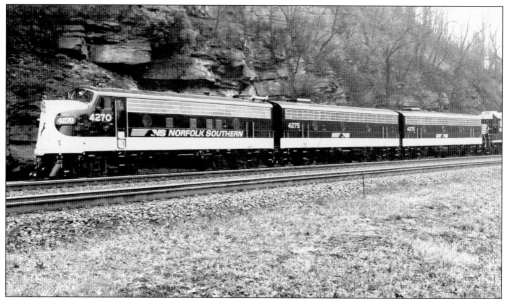

On April 26, 2007, Norfolk Southern's westbound Office Car Special stopped on Horseshoe Curve for an official photograph, but the weather did not cooperate as fog shrouded the mountain. Nonetheless, the train is spectacular in any light as FP7-A No. 4270, F7-B No. 4275, and F7-B No. 4276 lead the consist with the help of GP38-5646 as sister locomotive F7-A No. 4271 was not yet out-shopped. These locomotives debuted a month earlier with a trip to the Masters Golf Tournament in Augusta, Georgia. (Author's collection.)

The Norfolk Southern's gleaming Office Car Special stretches out on Horseshoe Curve on April 26, 2007, somewhat shrouded in fog, preparing to journey west and south to the Kentucky Derby in Louisville, Kentucky. These cars will transport railroad officials and Norfolk Southern's VIP shippers and guests to showcase the Norfolk Southern system and equipment. (Author's collection.)

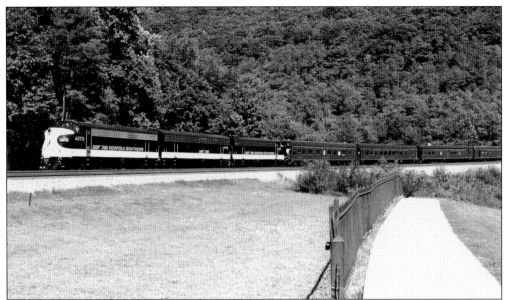

Norfolk Southern Railroad's very impressive office car train is westbound on Horseshoe Curve on September 24, 2007, led by FP7-A No. 4270, F7-B No. 4276, and FP7-A No. 4271. These restored and modified first-generation passenger-style locomotives are new to this train in 2008. Painted charcoal and pearl with gold lettering and striping, they provide the tuxedo look to accompany polished red and gold passenger cars. This luxury train's home base is Altoona, where all maintenance is performed. (Author's collection.)

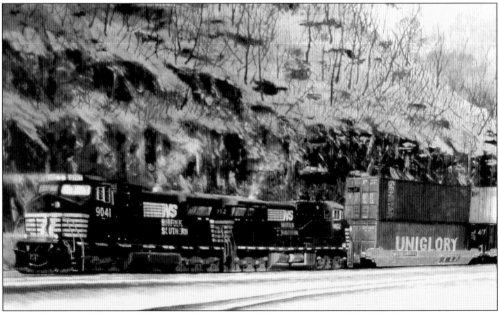

Artist Robert L. Hunt, of Altoona, has captured this impressive Norfolk Southern container train westbound on Horseshoe Curve against a winter landscape. Hunt is known for his portrayal of historic scenes, especially in and around the Altoona area and the national parks. His work was exhibited on Christmas tree ornaments in the Blue Room at the White House in December 2007. (Courtesy of Robert L. Hunt.)

Six

AMTRAK

The urgency of the Penn Central Railroad bankruptcy, which was exacerbated by mounting passenger losses, prompted the federal government to create the National Railroad Passenger Corporation, also known as Amtrak, effective May 1, 1971. Amtrak was to operate all passenger operations in the United States with the initial exception of the Southern Railway and the Delaware and Hudson Railroad, whose passenger operations would be absorbed at a later time. In stark contrast to the peak World War II years on the PRR's Horseshoe Curve when 50-plus passenger trains moved over the landmark daily, along with regular freight and war matériel shipments, including troop trains, the reduced number into the Penn Central era and the diminishing quality of equipment and service impacted rail passenger services in many ways. Amtrak was faced with the need to provide a passenger rail network nationwide. With limited resources, Amtrak has continually altered service and equipment over Horseshoe Curve in this corridor between New York City and Chicago. The ex-PRR *Duquesne*, the New York-to-Kansas City *National Limited*, and the New York-to-Chicago *Broadway Limited* were routed via Horseshoe Curve. As the years continued, the *Duquesne* was discontinued, and the *National Limited* was removed on October 1, 1979. Ultimately, the *Broadway Limited*, with dining car and sleepers, was abolished on September 9, 1995, appropriately retired with former PRR office car No. 120 *Pennsylvania* on the rear of the train. The *Broadway Limited* was replaced by the *Three Rivers*, albeit with sleeping cars but only an Amcafe for food service. Always in the name of cost-cutting (often resulting from loss of mail contracts), the *Three Rivers* also became a casualty, replaced by the *Pennsylvanian*, subsidized by the Commonwealth of Pennsylvania, providing service only to Pittsburgh with transfers to the *Capitol Limited* for travel to Chicago.

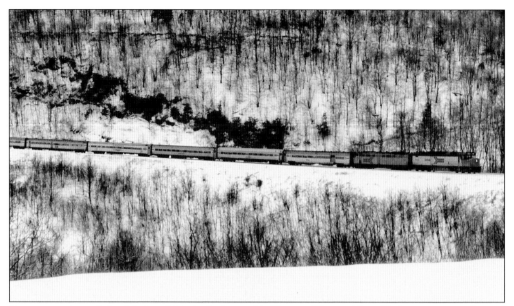

Representative of the *National Limited*, Amtrak's Kansas City-to-New York train is eastbound on Horseshoe Curve. The route was basically that of the *Spirit of St. Louis*, but Amtrak had extended the route to Kansas City. The *National Limited* name was originally that of the Baltimore and Ohio Railroad, which was borrowed and applied to the *Spirit* with a timetable change on November 14, 1971. However, the *National Limited* succumbed to budget cuts and discontinued on October 1, 1979. (Author's collection.)

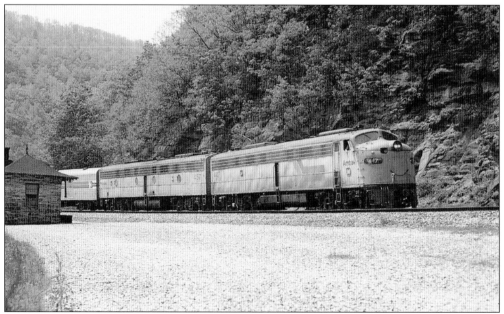

In this postcard view, Amtrak's *National Limited* powered by heritage E8-A 447 and E9B 457 glides downgrade around Horseshoe Curve, west of Altoona, with train No. 30, the eastbound *National Limited*, on May 21, 1977. This train would disappear in late 1979. Train No. 30 was the prior designation of the *Spirit of St. Louis* of PRR fame, but *National Limited* was a name from the Baltimore and Ohio's timetable. (Courtesy of Carl H. Sturner collection.)

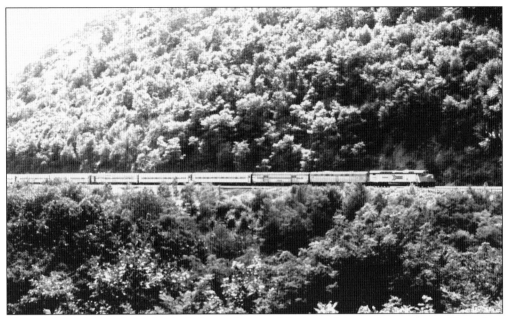

The eastbound *Broadway Limited* descends the Allegheny Mountain range to Horseshoe Curve on a summer morning. The heritage E-8 locomotives from the predecessor railroads are gradually being replaced by newer power as in this blend of an aging E-8B unit (cabless) trailing the modern SDP40F. This train is approximately seven hours from New York City, carrying coaches, sleepers, and dining car, unlike its predecessor all–sleeping car train of PRR heritage. (Author's collection.)

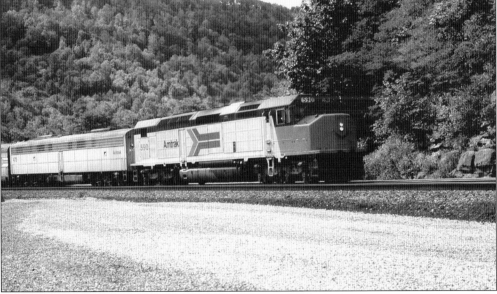

SDP40F locomotive No. 590 leads a heritage E-8B (cabless) unit in a continuation of the preceding photograph. The SDP40F locomotive was Amtrak's first new long-distance passenger locomotive, seen here at the apex of Horseshoe Curve. The engines experienced a series of derailments and subsequently lost the confidence of Amtrak, replaced after only eight years of service. (Author's collection.)

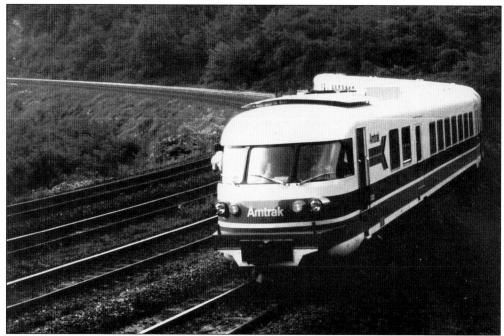

The day August 10, 1973, sees the experimental Amtrak French Turbo train westbound to the Midwest on its journey to Chicago. A revolutionary design, this train set did not see regular service on the New York–Chicago corridor via Horseshoe Curve but drew much attention as it passed through Pennsylvania, representing new Amtrak innovations. (Author's collection.)

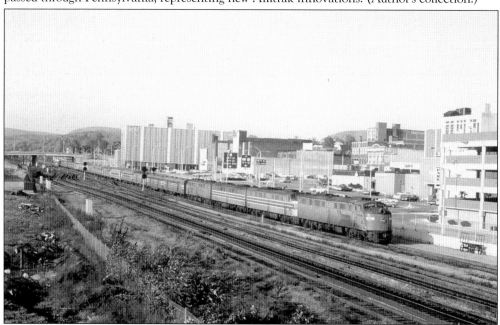

Amtrak's *Broadway Limited* arrives in Altoona, autumn 1980s, having just glided around world-famous Horseshoe Curve a mere five miles previous. This still-16-car train is classically styled with heritage E-8 locomotives from the streamlined diesel era. (Courtesy of Charles Houser Sr.)

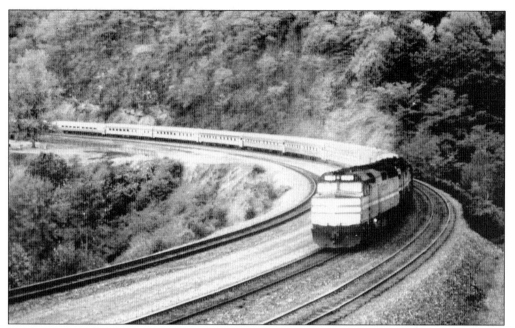

In this postcard image by Evelyn M. Smith, Amtrak's *Broadway Limited* is eastbound on Horseshoe Curve in the 1980s. Amtrak's new locomotive, the F40PH, which replaced the short-lived SDP40F, powers the train to New York City from Chicago. In this view, Conrail has removed No. 2 track, reducing the four-track "broad way" to three. (Author's collection.)

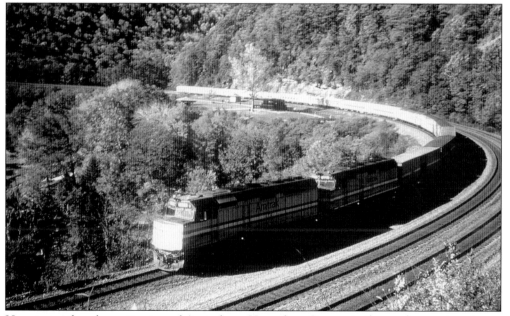

Here is another dramatic view of Amtrak on Horseshoe Curve, similar to the previous image but with differences. The *Broadway Limited* is now the *Three Rivers*, a much shorter train in passenger capacity but with added head-end cars for mail transport. Loss of such mail contracts in the not-too-distant future would impact Amtrak's passenger services on this famous route. (Courtesy of Larry G. McKee.)

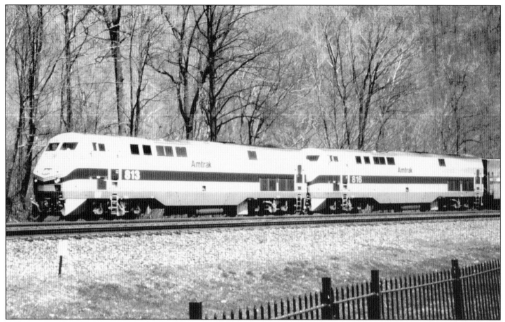

Pictured here is a duet of Amtrak's new Genesis I series locomotives by General Electric (P-40) westbound on Horseshoe Curve. Painted in the northeastern service paint scheme, the locomotives conveyed a streamlined appearance similar to that of first-generation passenger locomotives. Paired elephant style, these units power the *Three Rivers* toward Pittsburgh. (Author's collection.)

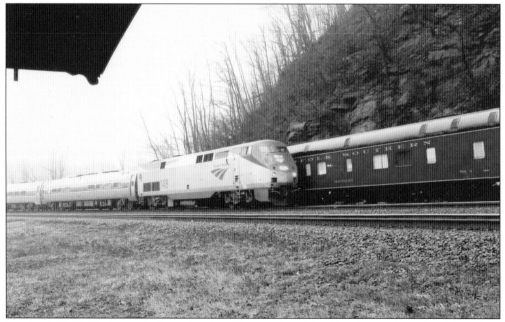

On April 26, 2007, Amtrak's *Pennsylvanian* (Pittsburgh to New York) is eastbound on Horseshoe Curve passing Norfolk Southern's magnificent Office Car Special, which is headed to the Kentucky Derby. Powered by a Genesis II model P-42, the *Pennsylvanian* has no checked baggage or mail. Four amfleet coaches trail with an Amcafe, due in Altoona at 9:50 a.m. (Author's collection.)

Seven

Horseshoe Curve National Historic Site

For 154 years, J. Edgar Thomson's Horseshoe Curve, by design, has been an engineering landmark, a geographical wonder, a premier scenic landscape, and a destination. The seasons enhance the landscape continuously as does the light and shadow that paints nature's canvas. Millions of photographers seek out Horseshoe Curve to frame in their lenses as the appropriate backdrop for the passing railroad scene. To use the sentence from the film *Field of Dreams*, "If you build it, they will come" certainly applies. From rough-hewn hills to humble park to national historic treasure, Horseshoe Curve not only serves the nation's constantly changing needs but the casual tourist and historian as well. The humble concession facility has grown to a formal visitors' center with historic exhibits and infrastructure. Handicapped accessible today, anyone can visit and experience the grandeur that is Horseshoe Curve. In recent years, the annual Railfest event sponsored by Railroader's Memorial Museum in nearby Altoona draws thousands to the area to either ride around world-famous Horseshoe Curve or to observe the passing trains. Juniata Terminal Company's magnificently restored PRR E-8 class locomotives and first-class cars draw visitors like the moth to the flame. This train set is a tribute not only to the history of the PRR, under whose design this system began, but to the Bennett Levin family of Philadelphia who cherish this history and share it with the legions who share this passion. Their Railfest excursion trains, on an almost annual basis, are admired by all who visit. Hopefully, a forestry management plan can be formulated in the future to manage the maturing tree growth, which is diminishing the expansive view that thousands come to see. The Horseshoe Curve right-of-way was maintained for over 50 years by Oscar Salpino (PRR, Penn Central Railroad, Conrail), as was Horseshoe Curve Park following his retirement; his stewardship of this geographical wonder is legendary and appreciated by all who arrive here to enjoy this special place. Salpino's legacy was his work ethic. His stellar career elevated him from laborer to section foreman to general foreman. As groundskeeper at Horseshoe Curve Park in retirement, he was a familiar presence, and the legions of visitors who encountered him were enriched by the experience.

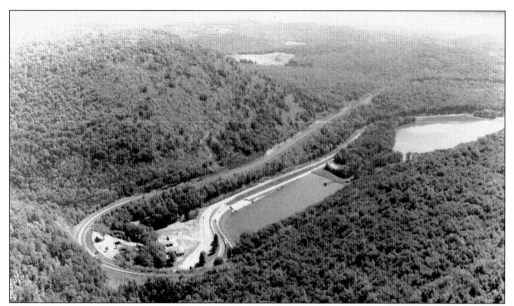

In this recent aerial view of Horseshoe Curve, the natural cul-de-sac that forms the bowl of Horseshoe Curve is seen. Such a view would not have been possible if it were not for J. Edgar Thomson's engineering survey crews of pre–Civil War times, when the region was a genuine wilderness. Their achievement, with the technology of the day, was certainly monumental and enduring. (Courtesy of Bob Hoffman for the Allegheny Mountains Convention and Visitors Bureau.)

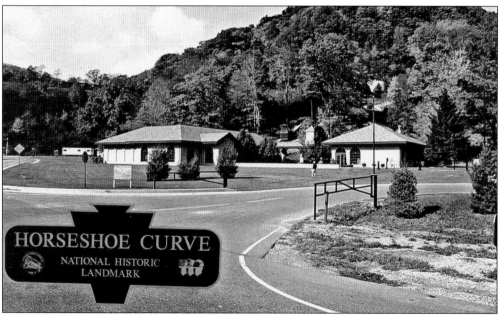

This postcard view clearly illustrates the magnificent setting for the Horseshoe Curve National Historic Landmark Visitors Center in this autumn view with brilliant foliage. The park welcomes visitors from all over the world and since 1992 has been handicapped accessible to all, especially the funicular that carries visitors up the hillside to observe the passing trains. (Courtesy of Thomas Pollard.)

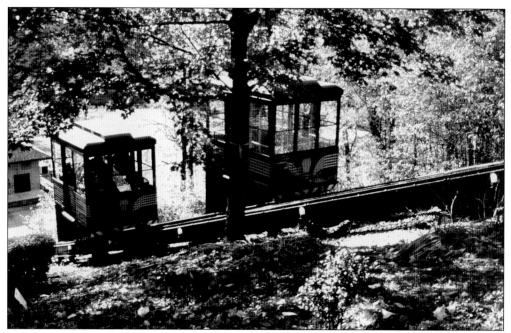

The funicular at Horseshoe Curve welcome center transports visitors up the steep hillside to railroad grade level to observe the passing trains. Until 1992, visitors with age or physical impairments were unable to enjoy the complete visitor experience. These cars are painted to replicate the Tuscan red with five gold stripes of PRR passenger locomotives. (Author's collection.)

This vintage PRR class F30A flatcar is a handsome addition to Horseshoe Curve National Historic Site. This addition provides not only a historic exhibit but also becomes a stage for band concerts on summer evenings. The expansive lawn fills with lawn chairs as people enjoy a cool evening in the mountains, and the music is enhanced by the symphonic steel wheel on steel rail. (Author's collection.)

In the almost 20 years since being placed at Horseshoe Curve, GP-9 locomotive No. 7048 began to show its age from exposure to the elements. Volunteers from Kittanning Trail Volunteer Fire Department (Ella, Paul, and Mike Cruse; Paul and Keith Tackas; John Andrews; and J. Smith) undertook the task of painting this diesel-electric locomotive, and their efforts are much appreciated by all who take their candid photographs near it. (Author's collection.)

The interior of the Horseshoe Curve visitors' center is festive with the yule tree. The design of this building with Roman arched windows not only lights the displays but also gives commanding vistas of the bucolic landscape that is Horseshoe Curve. Sights, sounds, and participatory activities welcome each visitor, young and old alike. (Author's collection.)

The Horseshoe Curve visitors' center, quiet in this winter landscape, has an architectural style complementary to typical vintage railroad design that is in total harmony with this forested location. Loosely inspired by the early-1900s Kittanning Point station, visitors have perceptive views of another time that beckons each new year. (Author's collection.)

In the evening at Horseshoe Curve during most Decembers, the Horseshoe Curve visitors' center is ablaze with lights in preparation for Santa Claus's annual visit. Usually arriving by train, Santa greets all the children (young and young at heart). On this December 22, 2007, occasion, warm cookies, hot chocolate, and coffee warmed everyone's spirits, and treat bags awaited the children while Christmas carols were provided by the Altoona Community Band. (Author's collection.)

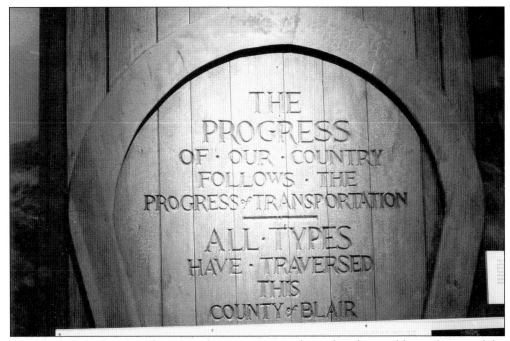

This placard, displayed in the original concession stand, was hand-carved by craftsmen of the Civilian Conservation Corps of the 1930s. This artifact is still displayed in the Horseshoe Curve visitors' center today. It remains, as does the original Horseshoe Curve, to remind visitors of all generations of the legacy that is Horseshoe Curve. (Author's collection.)

This art deco–styled Horseshoe Curve poster hangs on the wall of the *Warrior Ridge*, a first-class parlor car of the Juniata Terminal Company, richly depicting the history that was the PRR. This car visits Horseshoe Curve several times each year, either on Amtrak trains or special movements, but almost always during Railfest. The poster clearly depicts the PRR's four-track "broad way" that is Horseshoe Curve. (Author's collection.)

The *Railfest Limited*, with the richly restored passenger varnish that represents the PRR, has just arrived at Pennsylvania Station, Pittsburgh, after three round-trips over Horseshoe Curve on July 7, 2007. In the morning, this train will head for Horseshoe Curve to complete three additional round-trips for those who come to see this famous landmark. (Author's collection.)

PRR office car No. 120, at Pennsylvania Station, Pittsburgh, awaits a return trip to Horseshoe Curve. Used by the president of the PRR, the car also transported the body of Robert Kennedy on June 8, 1968, from New York to Washington following his assassination. Heads of state rode this car, and in 2007, His Royal Highness the Prince of Wales and the Duchess of Cornwall traveled from Philadelphia to New York. (Author's collection.)

A resplendent example of PRR varnish sits in Pennsylvania Station, Pittsburgh, on July 7, 2007, having just arrived from Horseshoe Curve, its destination tomorrow morning once again. Headed by E-8 locomotives No. 5809 and No. 5711 and first-class cars representing PRR design, this scene, and those on Horseshoe Curve, recalls another time as Railfest in Altoona becomes a magnet for railfans, visitors, and historians. (Author's collection.)

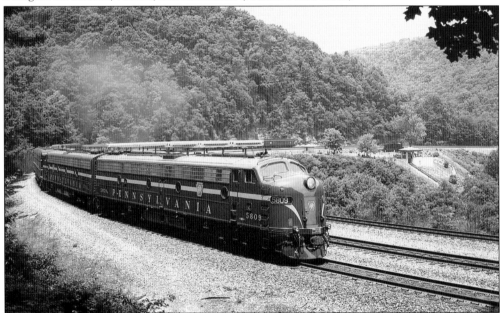

On July 7, 2007, at 12:45 p.m., the *Railfest Limited* is westbound on Horseshoe Curve led by the gleaming GM locomotives by EMD, E-8 No. 5809 and E-8 No. 5711. Formerly the locomotives of the Conrail Business Train, these units of PRR heritage have been authentically restored by the Juniata Terminal Company of Philadelphia, headed by Bennett Levin and son Eric Levin. (Courtesy of Tom Mugnano.)

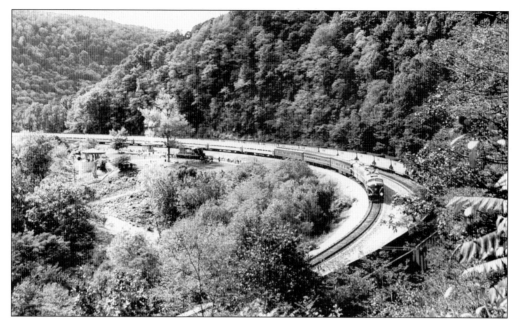

On October 5, 2002, the *Railfest Limited* is eastbound on Horseshoe Curve returning to Altoona. The famed E-8 locomotives No. 5809 and No. 5711 power the train, followed by office car *Pennsylvania* No. 120, parlor *Warrior Ridge*, the heavyweight Pullman *Dover Harbor*, and coaches. The Bennett Levin family's Juniata Terminal Company of Philadelphia graces Horseshoe Curve periodically with this PRR heritage. (Courtesy of Paul D. Molans.)

Railroader's Memorial Museum, operator of Horseshoe Curve National Historic Site, is also the primary sponsor for the annual Railfest, which draws many visitors to the world-famous Horseshoe Curve and to the Greater Altoona area annually. (Courtesy of Thomas Pollard.)

ACROSS AMERICA, PEOPLE ARE DISCOVERING SOMETHING WONDERFUL. *THEIR HERITAGE.*

Arcadia Publishing is the leading local history publisher in the United States. With more than 3,000 titles in print and hundreds of new titles released every year, Arcadia has extensive specialized experience chronicling the history of communities and celebrating America's hidden stories, bringing to life the people, places, and events from the past. To discover the history of other communities across the nation, please visit:

www.arcadiapublishing.com

Customized search tools allow you to find regional history books about the town where you grew up, the cities where your friends and family live, the town where your parents met, or even that retirement spot you've been dreaming about.